"The best thing to do with stereotypes and preconceptions is to challenge them, and this book, THE BLIND PHOTOGRAPHER, does just that. It breaks down barriers from both sides and shows what can be achieved if you turn your back on the doubters and just follow your dreams. Visions are not seen purely by the eyes but through the spirit."

STEVIE WONDER

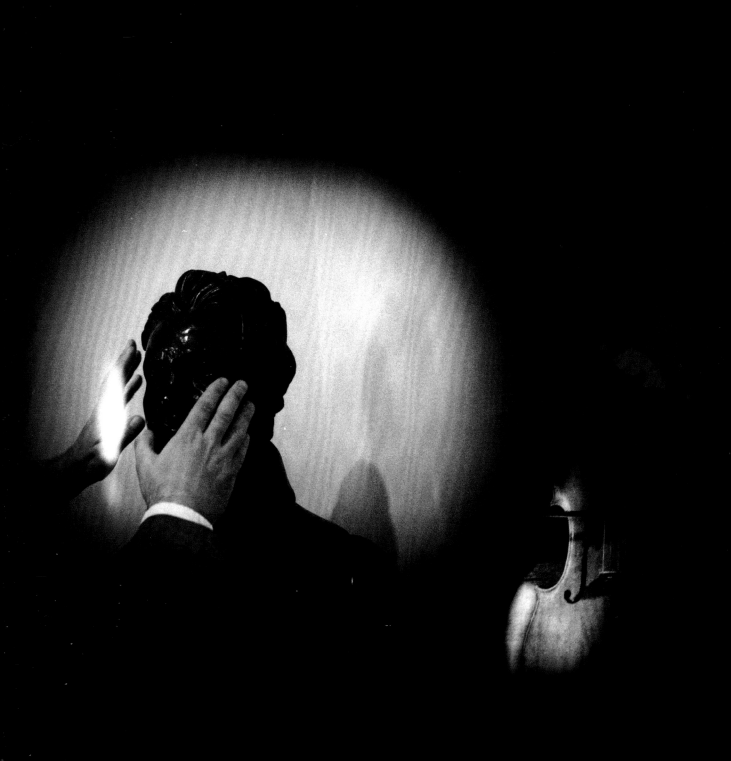

Evgen Bavčar. *Untitled.*

The Blind Photographer

INTRODUCTION BY CANDIA McWILLIAM

edited by julian rothenstein

and mel gooding

PRINCETON ARCHITECTURAL PRESS, NEW YORK

Princeton Architectural Press
A McEvoy Group Company
37 East Seventh Street
New York, New York 10003
www.papress.com

Published by arrangement with Redstone Press
7a St Lawrence Terrace
London, UK W10 5SU
www.theredstoneshop.com

Manufactured by C & C Offset Printing Co. Ltd., China
19 18 17 16 4 3 2 1

ISBN 978-1-61689-523-5

Design: Julian Rothenstein
Artwork: Otis Marchbank Production: Tim Chester

For Princeton Architectural Press
Editors: Rob Shaeffer and Jenny Florence
Cover Design: Paul Wagner

Library of Congress Cataloging-in-Publication Data
available upon request.

CONTENTS

introduction by candia m^cwilliam 11

how do they do it? 21
visions of the real: the desire and will of the blind photographer 23
by mel gooding

THE PHOTOGRAPHS 30

including special features: alicia meléndez 29 aarón ramos 40

tanvir bush 63 pedro rubén reynoso 79 mickel smithen 94 gerardo nigenda 119

alberto loranca 138 evgen bavčar 143 jashivi osuna aguilar 152

ana maría fernández 163 from india 169 pedro miranda 182

from china 203

afterword by jorge luis borges 213

eyes that feel

It is more difficult than it may seem to take a photograph of an object that conveys the felt reality of that object. You are being asked to make light solid by the way you see – or feel – it. You cannot, even if you should be fortunate enough to have the full use of your eyes, just creep up on an unsuspecting potato or a broken bowl and take its picture. You must fill the thing you see with feeling in order for the person who sees the taken picture to feel that potato, that broken bowl, as you felt them, the potato's thin-skinned heart-shaped crupper, the bowl's sad incapacity ever, whichever way you turn it, to reunite with itself.

You might say that what has been achieved in a successful picture of an object is an 'objective correlative', but you will rarely find less objective photographs than those that fill this book. It is nothing less than a magic lantern, painting with light and speaking to our memory, senses and humanity to make of images a story that makes sense to us. These pictures are often so full of emotion that the experience of looking at them is insistently companionate – the prickly flowers against the curtains with their unchintzy bunch – and consistently expressive of a solitude that is often reported by those whose life is visually darkening or dark. Solitude not being loneliness: to look closely at these photographs is to be humanly remade by the refusal of these photographers to objectify an atom of the experienced world, recorded here with what we could call felt sight.

The impulse to touch with a fingertip, to smell, to place one's ear to, to drink, to taste (to take the butterfly and set it free from within the net of the curtain that shades the curly wrought-iron window-guard beyond), to eat or kiss these pages, is never far away. We feel how it is to have one's three middle fingers deep in a bowling ball, the weight of it.

Weight is everywhere here. When you cannot see, you feel the different weights of things and steer and make decisions by that: through curtains; against a wall; into water. Sunlight weighs differently from twilight; it stills you, dazzles, is not wholly a benign relaxant or an ally.

Perspective is scale is size is perceived weight; we see and feel this throughout the book. The young man in the blue t-shirt who covers his face with his improvised barbell against a concrete wall looped with barbed wire raises the weight, and in the same moment we seem to see an equivalent weight lifting itself from him. Later, the world is thrown up in the air.

The beautiful work assembled here is made mainly by differently and variously visually-reduced inhabitants of the megalopolises of the developing world. *Ojos Que Sentien* is a shining, disturbing, accurate name for the organisation to which most of the Mexican photographers belong. Eyes are 'feeling', although they are just leathery bags of jelly and physics. They are sympathetic with one another, in a way that spells great concern for a person who has a disease in, or sustains damage to, but one eye. The other eye may take sympathy as far as it can and put out its own lamp. It is not a spare.

To feel such wet freshness, as though from a bath of chemicals, in photographic work – as arises from the images carefully set down in this book – one must consider the earliest days of photography itself, when it was beginning to bloom and ripen in the consciousness of the observing and entranced world, rather than what aspects of it have become. Instagram is named for undeferred gratification and for the telegram, something E. M. Forster, in *Howard's End*, 'connects' with his persisting unhappy prescience:

"The truth is that there is a great outer life that you and I have never touched – a life in which telegrams and anger count. Personal relations, that we think supreme, are not supreme there."

We are by now habituated to seeing things unfresh through lenses and screens; they have been caught, suffocated by the seizure enacted upon the seen, so that the image may be passed on as a sumptuary assertion – a 'grab' – more to do with acquisition than apprehension; a thing no sooner seen than cling-filmed, rendered airtight, part of a sticky yet sharply damaging, binding and deceiving ground-glass sharpened web, envious and cutting, that can throttle and sever actual social connections and some proper sense of self. Shutter exposures have shortened in length of time but some kinds of exposure, it would appear, cannot ever be undone.

Here in this delectable album, to redress such ghostly affectless snatching and passing along of unreal presences, is a just-pinned-up washday of fresh unfurling pages. Each reveals the private marks of wear that the psychology, or we might say spirit, of the photographer has sustained in his conversation with the dark when it is arriving, in the wrong place at the wrong time, like dirt.

The conviction to be found in these photographs consists partly in their having been, with hand or heart, fully felt before having been taken, rather than smartly pickpocketed from the ongoing self-conscious movie that life has become for some, every moment a cold 'still' sliced from the flow. We can all be the directors and story-boarders of our lives now, though it may be lonely when the credits roll.

In these pages, placed together with as much intent and process as rod and cone cells are positioned at the back of each species' eyes as to equip them for the kinds of vision their possessors will require (nocturnal, subaqueous, 360 degree), beams forth a story of the connective light that photography can shed, and how it can draw human souls with, as well as into, its light.

It is very difficult, in English, to avoid words of 'seeing', or of 'light'; everything suggests sight to those whose eyes are under threat. There are snuffers-out of light everywhere.

A particular decorum is offered to (and expected from) the visually compromised, but it is hard to abide by its law, which is that nothing seen or to do with sight should be alluded to, in order to spare everyone's feelings. Friends self-consciously deploy semantic niceties; spontaneous wit is curbed; tactless strangers can be a relief – and then it may all be too much. It can be a case of never playing I-spy again, when you are locked up in a human body for the whole journey and cannot wind down the blacked-out windows (note the trembly, thin, incontrovertibly lowered blinds that answer the redeeming lens, and the pile of objects making up the 'blind-person's kit' entitled *Cruelty*). Conversations about books, for example, are skirted (see the toothless typewriter; like a clock with no hands, a typewriter offering no keys); and, more trivially, conversations about skirts and all implied thereby may be lost. Let alone chat about the sky, the moon, the disposition of the stars.

This can come about unless the sight-deprived can find a way to alleviate the burden of being 'understood' through a misunderstanding, a not-thing that makes the hale think that you are a less-than, a nothing who lives in a dark of one colour only, and has always done so. That the darkness of the blind is various and changing is attested to by each blind person, including those blind from birth. Light differently penetrates most forms of blindness. With it may come fluctuating colour, soft sheddings of light, small like clothes-moth wings, or any number of other suggestions of the world beyond the differently-lit self.

One photographer among those foregathered in *The Blind Photographer* describes her work as being "like a partner to me". When those compromised in bodily health are described, it is so often as though their sickness is their other or sole self, as if it is all the companionship they require. But for this photographer, the art takes the place of all the heart has lost.

Blind people, or those adjusting to closing sight, often have to take longer to do things. There are practical reasons for this. Falling is a possibility. Trust in an environment must be established. Atmosphere must be tested. The social bathyscaphe is employed. Faces cannot be read. Love at first sight is not going to happen. Swift escape cannot be made. A kind of sonar depending upon intuited locations of all kinds of presence or even threat may develop with practice. Practice itself takes time.

The taking of time, armfuls of it, handfuls of it, thimbles of it, is manifest explicitly and beautifully in the texture of these photographs (the pink towel – its fibres so soft and dense you feel you can hear them growing; but silently, like moss; you want them on your cheek). Touch is everywhere. Texture presses upon the viewer. Looking at these pictures is like going to sleep hard in the afternoon on a pillow trimmed with old-fashioned crochet, or walking on a hard plastic toy (see Tanvir Bush's magnificent jerry-can lorry; Alberto Loranca's *Fighter*); you feel it with your thinnest skin, your most richly nerve-provided extremities; you are imprinted.

In Alicia Meléndez's photographs of paper boats you find your hands reaching for a sheet of paper to make the familiar childhood folds – you might say you could do it with your eyes shut – and you know exactly what to do as long as you rely on instinct only, fold, fold, feel, fold, turn it in upon itself, tug modestly hard, remembering that this is paper not cloth and can develop weaknesses should you be importunate. Having been returned in time to childhood by the photographer, you are pushed even further back, into infancy, when the thing to do with

everything new was to bung it in your mouth. This is one way of experiencing the world if you cannot see; you eat it, lick it, taste it to test it, let it arrive upon your tongue like fruit, like Pedro Reynoso's sexy apricot and the watermelon reversed and split in image by the stem of a glass; the bananas of Gerardo Ramirez reverse this and come at us as though we are ants and they the noses of futuristic anteaters.

Many of these photographs experiment with scale, which is a playful and dead serious manner of addressing the way it can feel to be overlooked because, as others understand it, you cannot look. But of course, behind your eyes resides the sense that feels strongly the gaze of another person, including through the back of the head.

Each of the photographers in this book has taken time and taken time to heart. You could swear that you could rip Jashivi Osuna Aguilar's sticky metallic paper hearts and hear them pump and crackle like festive sticking plaster, like postoperative helium balloons. Can you mend a thinned heart? There is every practical, surgical, biographical, and metaphorical reason for the photographer to be preoccupied with that exact question. The snapped-on gloves, the mussed heart plastered on the wall, are images that declare the state of the photographing heart.

An iridescent soap bubble, pierced but not broken by a long stick, trembles opposite a rainbow-fibred mop-head with its alert handle and attendant bucket; two bottles, one water, one maybe bleach; the distinction comes into our sinuses as we imagine sightlessly almost drinking from the wrong one. We hear the wind whoop low in the brief imperfect irregular bubble, the best fun a person of any age or ability can have with the rainbow.

Hope quivers in these photographs; not the sentimental hope that offers a tidy 'cure'; rather the hope that tomorrow may bring some new way of expressing life as it is felt.

Dreams are often harvested from places we are unaware we have been; they offer the forgotten you forgot you had forgotten. In several photographs, these things are summoned with the vividness of a scent, or, more terribly, the passage of a ghost (see Mikel Smithen's dancers and the images of Evgen Bavčar).

Aarón Ramos's empty snail-shell asks us to crawl into it and to be laid in earth; his cosmos flowers with their almost surfaceless leaves seem to be as thinly but perfectly alive as the wing of an insect or the fascia of a muscle; the breeze stirring them passes through many of the textiles in the book. The shadow of the bright stamens makes eyelashes in the flower's face, as clear as those around the eyes that look through the oval of card.

Meléndez's empty shoes, that subvert the cliché that you can tell everything about a woman from her shoes, anticipate Ana María Fernández's orphaned little pink Crocs with their decal butterflies on big grey tiles; they pin down the book's many other actual, fragile butterflies.

And it all leads to the picture that comes last, the dandelion clock in China, whose fuzzy yet geometrically perfectly evolved head is many times the size of the heads of the human individuals behind it. Will the photographer blow upon the seed-head with its hundreds of little parachutes, each holding a seed of that alive, insistent flower that will not be rid of and is said to make you wet the bed?

I asked my computer whether blind people dream. I was led to a site where, seven years ago, an individual whose *nom d'ecran* I will protect, had written these words: "I love it when people ask me these questions. I have been blind since birth and dream. My dreams have the people I know in them. The feel of their face and sound of their voice is all the same in my head as it is in reality. The only thing I wonder is, is blue in my head the same blue in everyone else's eyes?"

Beautiful, not unintentional, poetry aside, it is the question humans possessed of all degrees of sight have asked themselves; it is the question of whether my reality is yours. It is the question that we ask about the ancient Greeks when we wonder why it is, in a maritime nation, under the bluest of skies, that their language seems to have thrown up no word for what we call blue, but rather only for different degrees of darkness and lightness; one might call it a photographic understanding of the chromatic.

Blind people cohabit very closely with themselves; whether this leads to self-knowledge, I cannot say. I can imagine, or so I imagine I believe.

The full imaginations lying in plain sight on the pages in this book repeatedly touch and enlarge the heart of the person who is looking at and into these pictures. I have not gone into the biographies of the photographers in this short introduction, for the important reason of innocence; because there is no possibility, once you 'know' the attendant stories, of unknowing them, and that may cant your reading of these profoundly shaking photographs. Several of them do seem to shift and quiver on the page, where light is caught and held: in a swimming pool, over images of Braille texts, on the swerve of a zebra's tight striped hide or that of a shower cubicle's near-kinetic tiling, on Bavčar's bitterly affecting photograph of hands on what looks like a blown-up passport photograph of a child, sepia in tone, and who we feel is long gone.

Look into the blunt felted face of Harley Allison's porridge-grey teddy and write the several stories in your mind: can you feel his texture because someone else can? Who else can? What are they to one another? Is the picture less appealing to you or to me, more appealing to someone who sees differently from how we may see or not see? Do we not all see differently? Isn't the pervading gentleness so absorbing as almost to improve you? Is my Heavenly Blue convolvulus your mauve Morning Glory? Do we just call it blue?

Is it not more important than ever to try to see as another person does rather than to insist upon one's own way of seeing, or not doing so?

> Does it matter – losing your sight?....
>
> There's such splendid work for the blind;
>
> And people will always be kind,
>
> As you sit on the terrace remembering
>
> And turning your face to the light.
>
> Siegfried Sassoon, *Does it Matter?*

It is the blinded (this word intended) view of blindness that Sassoon satirises here, the do-good neglect and patronising belittlement. The photographers in this book, have elected, in the most testing of circumstances – grave illness, poverty, desertion, intense loneliness and near utter loss of hope – to look through the dark and feel inside it for its opposite – the light that may all but be touched (as Satvir Jogi's hand holds the fuming apricot of the sun as it sets).

The missing ingredients are emotion and time. It may take a very short time to catch a photograph, but the stalking, baiting and waiting, the antecedent life, have all been building up to that decisive snap of the shutter on the taken scene. Technical aptitude, experience and proficiency may achieve a good deal, but one can still tell when, for example, that potato or that broken bowl is posed. Or, for that matter, when they are posing. And if you don't think objects can pose, please look at the apple hogging it on the pavement, the custardy jellies on their shelves, that utterly poised and wholly vulnerable nude spinning top, that old woman in her wheelchair by the fountain. Which is receiving the proportionate allocation of attention?

One miracle of this miracle-packed book is that it develops in us the conviction that the scene need by no means always be *seen* by the possessor of the sensibility who gives us the photograph. We have to turn our notions about seeing upside down, as the brain 'rights' the upside-down image we first apprehend. For objects, scenes and moments of perception to be remade for us, so that we may step into the shoes of the photographer, they need to be seen anew. It appears that what we learn from *The Blind Photographer*, lucky as we are to look into its fabulous pages, is that this tender capture need not be made solely with the covetousness of the eyes. Rather it is with the common connection of the heart; the ways it will find to carry on the work of interpreting each life it sustains, no matter how beaten down.

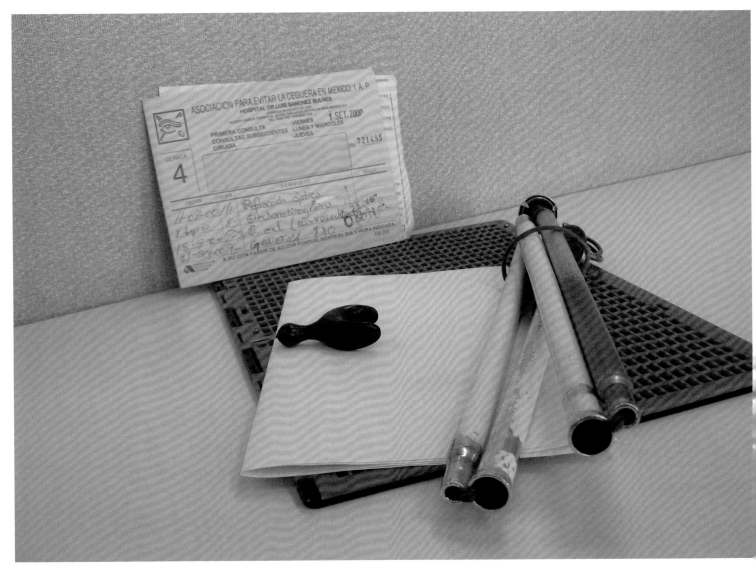

Berenice Hernández, *Cruelty*, Mexico, 2005

Someone, blind or not, might say: how cruel to be blind. This certificate, these accoutrements – a braille printing set, a collapsible white stick – are enough to signify: what? Hernandez is blind; these things identify Hernandez. But the photograph of the arrangement is a third thing. The first is: things possessed and known. The second is: things placed and photographed. The third thing is: Hernandez knew these things; Hernandez arranged these things; Hernandez *took* this photograph.

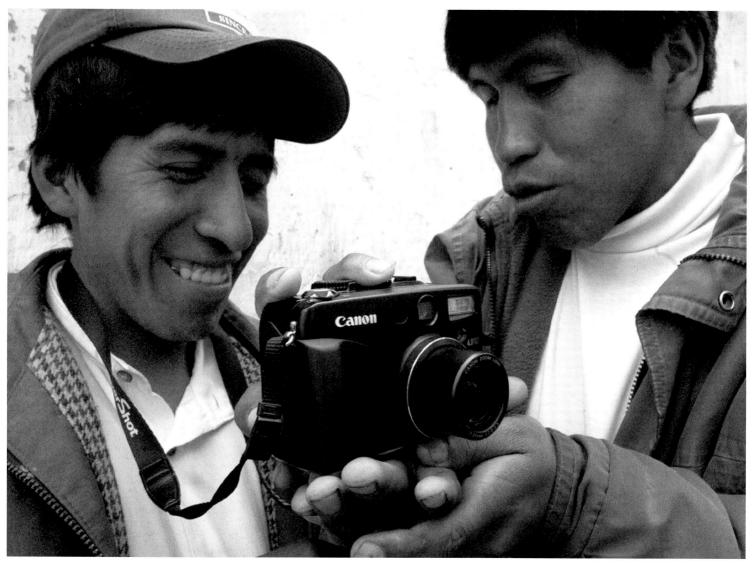

Christian Lombardi, *Javier teaches Santi*, Bolivia, 2012

A man smiles. A mentor with concentrated intent and a firm grasp fixes the camera in his hands: a photographer will begin his work. A world awaits its replication; a moment awaits its redemption. A blind man prepares to present to those that see something to look at! This, and the touch of hands, explains the smile.

José Sebastián Muñóz, *Untitled*, Mexico, 2012

The eyes are windows.

HOW DO THEY DO IT?

This is the question most often asked by people when they first hear about photographs taken by the blind. The answer is much the same as that of the broader question: How does anyone take photographs? It is: in many different ways. It depends on the sort of photograph different people *want* to take, on the circumstances in which they find themselves, on the diverse motives and purposes they may have for taking a photograph, and so on.

The machinery of photography is fundamentally simple: it is designed to catch the image that light creates on objects by means of a lens and mechanical processes (these vary and develop in sophistication, but the principle doesn't alter). Being blind or sighted, having a camera, having a subject and a desire to make a visual image of it, the camera is pointed in the right direction and a button is pressed. Hey presto! A photograph!

Some sighted people have become very skilled at manipulating the devices of light measurement, the length of exposure, colour and tonal modification, etc. Some have not: I am among the latter. But the huge number of possible uses to which photography has been put has taught us that the use of these technical devices does not necessarily increase the interest of a photograph, or affect the value we place upon it. We, the sighted, look at photographs in a hundred different ways. We look for different things, for different purposes. We make judgments accordingly.

The most sophisticated photographers in the world have often used the simplest cameras in the simplest ways; the most skilled and technically proficient photographers using the most advanced gear cannot guarantee that others will find their photographs interesting, beautiful, useful, or valuable. Moreover, no photographer, however accomplished, *can know how any photograph will turn out*. Most professional photographers in any field take many in order to find out which shots will be successful, in whatever terms are relevant to a particular 'shoot'. Think of those innumerable contact sheets, in which, out of dozens, one photo is selected!

The blind photographer has – like every other photographer – *an idea* of what he or she wants to achieve. The blind photographer has a body, a mind, a purpose and/or a desire; the blind photographer spends life in complex relations to other people, sighted and blind, and to objects in the world. Like any other photographer he or she may seek practical help and advice from others: to adjust the camera, to set up a subject, to catch an image on the wing using the simple machinery of the camera. What the sighted viewer makes of an image is a matter of individual response, just as it would be to any other image. From the exchanges of such viewers, the interest, usefulness and value of a particular image in the vast world of such images will be determined. The blind photographer takes photographs just like any other photographer.

visions of the real:

the desire and will of the blind photographer

1. DARKNESS AND LIGHT

The eye, it is said, is the window to the soul. But what if blinds have been drawn across that window? In a darkened room, the mind thinks, the imagination constructs and shapes reality, and the spirit animates: each does so in their characteristic and unpredictable forms, each with their necessary vigour. Thought and feeling are as one. For the blind person, all is in "the mind's eye": that is a faculty shared with the sighted when the room is in darkness, or the eyelids closed to the light. The blind Slovenian photographer Evgen Bavčar wrote: "Even a blind person has visual equipment, optical needs, as someone who is longing for light in a dark room. From this desire, I photograph." To look at photographs taken by the blind is to recognise this desire as one shared by all: in this way, these photographs are a revelation of the world of light, a manifestation of a common longing, a triumph of creative imagination, creations of the mind's eye rather than the brain's.

In recent years, photography by blind photographers has become a worldwide phenomenon. This may surprise us. Photography created by those who cannot see may appear paradoxical at first (the very word *photography*, after all, comes from the Greek, 'drawing by light'). But is it necessarily so? We are used to the idea that the loss of one faculty enhances the acuity of those that remain. Looking at the photography of the blind we encounter the paradox that it is sight itself that seems sharpened by blindness. Even the most severely blind person must have a vision of the world, created imaginatively with the help of the other senses, to answer to Bavčar's 'optical needs', a sense of things in space.

In contrast, the camera itself has no 'sense' of things, no 'eye' (in spite of the common metaphor), no brain, and no creative mind; it is nothing more than a machine that catches the light of a given moment; it cannot create meaning. But, like everybody else, the blind live in the world of light whether they can 'see' it or not: the mind's eye imaginatively 'pictures' the world, senses the relations between things, plucks meaning out of the flux of everyday experience. Memory is likewise a common faculty, however idiosyncratic its individual operations. The camera may thus be seen as a *visual aid*, so to speak, a technology by means of which the blind photographer may present to others something imagined in the mind visible in the common light. It makes things appear.

Since they cannot see what light refracts into the mind through the lenses of the eyes, or what the camera plate registers on its momentary exposure to the light, the blind must use other information to construct the picture of the world necessary for sustained communication. And of course, blind people (in most cases) are in constant communication with those who are 'sighted'. Reality, in fact, is a marvellous collaborative construction: the shared, continuous construing of what we might call the contingency of the actual. What is occurring? What might it mean? This coherence –always necessarily provisional– that we call 'the real' is created by the blind and sighted alike. In the light of this shared world, we might well ask: *why* has it taken so long for photography to be recognised as a vital medium for this constructive exchange of understanding between the sighted and the blind? Looking at the photographs in this book, it seems such an obvious and inevitable facility of communication!

The Blind Photographer offers to a wider public than ever before the extraordinary vibrancy and diversity of the work of blind photographers. It showcases brilliant and moving images from Mexico, India, Europe and China. It discovers many aspects of that shared reality and of its diverse mediations, infinitely different in kind as they must be: in the absence of sight, they have been created out of the imaginative complex of touch, smell, taste and hearing, presenting themselves as images pure and simple to that very faculty of sight. Helen Keller taught us, of course, that even when there is more than one sense absent, a rich world of shared thought and feeling might be brought into being. The mind of such another, its mysterious operations shaped and tempered by feelings we cannot possibly divine, will often surprise us with its unpredictable projections and discoveries. Thus our own mind is expanded, our imagination enhanced.

The book is not a history of photography by blind practitioners. It is, rather, a thrilling presentation of the work made by such photographer-artists. It is an anthology: as the etymology of this word implies, it is a gathering of divers flowers. It serves to remind us that there is indeed a great diversity in the condition of blindness: the experience of blindness is different for every blind person, just as sight is a function of personal history, experience, temperament, culture and social situation. Some are born blind; some have blindness thrust upon them. Of the latter, some have a residual visual perception of the world, however shadowy or vague; some have light or colour sensations; all have memories of the seen world. The work of blind photographers is as diverse in content and manner as that of their sighted peers.

All blind people must imagine the space they inhabit, and there is no living space devoid of objects. As with the sighted, the blind spend their days and nights negotiating these objects, near and far in their circumambient space, objects that necessarily possess sensible characters of colour, form and scale, qualities of hardness and softness, roughness and smoothness, etc. Among those objects are, of course, the myriad other creatures, human and otherwise, that share this living space. A photograph cannot by definition reproduce what we might call *the sense of presence*, the affective relation of objects to the living subject, though it may suggest it to the receiving imagination. The camera itself can do nothing more than register light in space and on the surfaces of objects; the space that the sighted share with the blind; the objects with which the blind and sighted alike continuously interact.

These relations with things in the familiar places in which we live create the very texture of our being: they are existential and not abstract, they shape our sense of a life, *our* life. It may be the case that the blind cannot see

these things, but they can, as we see, photograph them with powerful affect; as with the sighted, these things are the very substance of their physical and experiential habitat! Modern psychology has established that our senses are not simply or absolutely separate and autonomous, but that thought, memory and feeling are inextricably linked within the complex of our daily experience of the world. No one sense, in other words, can function in isolation from the others. For all of us, the world is realised out of the interaction between them, and the absence of any one sense in no way changes the principle of this psychological complex of sense and sensibility. Into each encounter with the objects in the continuous space of the world, the blind, like the sighted, take their bodies with them; each with it's distinct and complex sensorium, each with its concomitant mind and imagination. *Every* photograph is a record of such a sensational encounter: with people, buildings, walls, fruit, flowers, toys, the street, the kitchen, the living room, the bedroom, the beach, the pool, sunlight, darkness or shadow. Blind photographers take photographs because photographs are there to be taken.

2. CERTIFICATES OF PRESENCE

In his *Little History of Photography*, the critic Walter Benjamin writes of the 'magic value' with which photographic technology may invest its products: "No matter how artful the photographer, no matter how posed his subject, the beholder feels an irresistible urge to search such a picture for the tiny spark of contingency, of the here and now, with which reality has, so to speak, seared the subject, to find the inconspicuous spot where in the immediacy of that long-forgotten moment the future nests so eloquently that we, looking back, may rediscover it." We cannot look at a photograph without an awareness of its place in time: what we look at is in the past, in its own time, not ours. And there we see touching evidences of that actuality, things perhaps unnoticed by the photographer or irrelevant to his interest: an undone shoelace, a scar, an unshaven cheek; a moment's look of fear, of joy, of indifference, simultaneous to the shutter's click; a picture crooked on the wall, a crack in a cup, a curtain's breeze-filled billow.

That searing "spark of contingency" in a photograph is what Roland Barthes in his great book *Camera Lucida* called the *punctum*: "that which pierces or punctures me"; it is the *unintended* detail that interrupts the sought-for coherence of the photograph's studied composition. Such 'composition', however determined, is necessarily the work of an instant, the instant of the finger's press on the button, though it may have been (and usually is) carefully prepared for. Indeed, the photographer may have lain in wait for "the decisive moment" to occur, may have set up the scene or the still-life tableau, or patiently anticipated the circumstances that will give a photograph its purpose and interest (the field of such intent interest to the photographer, and the purpose of his engagement with it, is what Barthes called its *studium*).

Blind photographers work in as varied ways as sighted photographers, and the space of what Benjamin called "the optical unconscious" will inhere, by definition, equally as surely in the images they create; "For it is another nature which speaks to the camera rather than to the eye: 'other' above all in the sense that a space informed by human consciousness gives way to a space informed by the unconscious… It is through photography that we first discover the existence of this optical unconscious, just as we discover the instinctive unconscious through

psychoanalysis." The natural scientific processes of photography (chemicals reacting to light; photo-detectors capturing images digitally) have, of course, no purposeful intention. The blind photographer can, no more than the sighted, possibly know in a photograph where such a "spark of contingency", such a sharp *poignancy*, may occur. He must know, however, that this potential is in every photograph he takes, for his intention in every case is ineluctably subject to the chance and circumstance of the instant, and he is aware of his own blindness as a component of that instant.

The camera registers, for sure, the visual field and its objects, the "subject" of the photograph, but this is itself as invisible to the blind photographer as that revelatory item or aspect within it, the product of the optical unconscious, that unintended detail that "pierces" us. It may be visible, however, more or less sharply, to the spectator; it may in fact be a different detail for different people: what "touches" us in that way will differ according to our temperament, or the mood of the eye. The blind photographer, moreover, must in every case be instinctively aware that such contingencies may move to centre stage, so to speak, may *become* the (unintended) subject. This sharpens *our* constantly poignant sense of the "here and now" which imbues these images, the contingent 'reality' that in each case has "seared the subject". What this book indeed offers is an opportunity to re-examine the whole theory of photography (ramshackle as it is) in the light of the *volition*, as well as of the indubitable artistic *vision*, of its unsighted practitioners.

"The photograph is indifferent to all intermediaries", unlike language which, as Barthes writes, is "by nature, fictional", – "it does not invent; it is authentication itself…. Impotent with regard to general ideas (to fiction), its force is nonetheless superior to everything the human mind can or can have conceived to assure us of reality – but also this reality is never anything but a contingency…. Every photograph is a certificate of presence." The work of the blind photographer is, as it is for the sighted, thus an act of wilful self-authentication, a sign and assertion of presence. The "decisive moment" in these photographs is not that of Cartier-Bresson's famous "event", caught, captured, *taken*, as we say; it is not 'composed' in an instant's visual recognition, in which the camera is conceived as a technology of observational agency. It is rather that of the photographer's own act of photographing, it is the decisive moment of authorial realisation: it registers being-on-the earth, here, now. It is a moment not of external chance and circumstance, but of creative will and existential purpose.

Photography can fulfil many purposes: expressive, observational, forensic, documentary, instructive, celebratory, and so on; it can be immediate and spontaneous in its response to objects and events, or premeditated and controlled. We can no longer talk of a 'good' or 'bad' photograph so much as consider its fitness for purpose or its evocation of feeling. Effect or affect. Or both. Banal snapshots and the amateur pictures in the family album (for example) carry the poignant charge of their moment of exposure: of what the photographic theorist André Bazin described as their "embalmed time": "… Photography does not create eternity, as art does, it embalms time, rescuing it from its proper corruption.'" There are no 'bad' photographs, but there are many that do not interest us, and there are certainly some very good, and some very beautiful ones, and some that are useful: it is the spectator who *in every case* decides.

This answers a question often asked about blind photographers: "How can they know if their work is any good?" What applies to photographs in general applies to those by any particular blind photographer. As the great American street photographer Garry Winogrand has suggested, the photographer can only be aware of *possibilities*. *No* photographer can know what his photograph is going to look like: "I photograph to find out what something will look like photographed." And that is just what it 'looks like' to someone else. It is that other – the spectator of the photograph, *you* who look at the photographs in this book – who will decide if it 'works' or if it moves you.

We live at a time of ever-increasing digital facility, of photography as the means to repetitive banality, to a tiresome meaninglessness of arbitrary record, to absolute immediacy and instantaneous forgetting. Now more than ever we might properly find a joy and excitement in these photographs: out of necessary and diverse subjectivities, existential predicaments of darkness or shadow, they are projected into the common light we all inhabit. They are a medium for understanding and for pleasurable interaction in both directions: they provoke both the blind and sighted to imagine the condition of the other more fully. And they celebrate the deeper truth, known and demonstrated by artists, writers, dramatists and musicians over the many centuries: that blindness is a kind of seeing; and that those who can see are often blind to the strangeness and beauty of the world about them.

MEL GOODING, London, April 2015

A Note on Texts: 'Little History of Photography' (1931), translated by Edmund Jephcott and Kingsley Shorter, is included in *Walter Benjamin Selected Writings Volume 2 1927-1934* (Harvard, 1999). Roland Barthes's *Camera Lucida* (1980) is translated by Richard Howard (London, 1982). *The Decisive Moment* is the title of Henri Cartier-Bresson's 1952 classic volume of photographs and reflections. André Bazin is quoted from his seminal essay *The Ontology of the Photograph*, in *Film Quarterly*, Vol. 13, no. 4 (California, 1960), translation by Hugh Gray. Gary Winogrand is quoted in 'Certainties and Possibilities', in *Diana & Nikon: Essays on Photography* by Janet Malcolm (New York, 1997).

ALICIA MELÉNDEZ

"One day, more than 5 years ago, I woke up to find that I was able to see only a kind of moving veil. I was told that I had suffered a retinal blow-out. I am at last beginning to recover from the deep depression this caused. It has been a struggle to come to terms with my condition, but I am now beginning to succeed. Photography has sustained me through these travails; each click of the camera is an achievement that enhances my self-belief…."

Alicia Meléndez has retained a remarkably acute sense of the visual-tactile from her life before her blindness. Her photographs, often in sequences, present autobiographies. They are self-dramatizing performances in which she is represented, or, more accurately, *played* by surrogate objects – shoes, vegetables, paper boats, etc. – whose physicality is sharply emphatic. Variable selves are objectified in these poignant presentations.

Such a self may suffer a sense of entrapment: her worn and empty shoes in an enclosure.

Such a self may seek to be free of constraint and immobility: "*I have liked paper boats ever since I was a young girl. The boat is me. If the boat is out of water, motionless and impossible to navigate, it is useless. But, if we place it in a suitable context, it floats, it flows and it is whole and free.*"

A potato presents itself to her hands, and to our eyes, as an embodiment of female sexuality; a bowl of shelled peas invites the plunge of a hand that will discover the alienated discreteness of every atomic item in the aggregate and feel the flow between them.

Meléndez is always a *dramatic* presence in her photographs: a *mis-en-scène*, an intense identification with a tangible object, an unresolved act. "*I enjoy constructing images in my mind, and when I resolve something and take the picture I feel that I can see. Before losing my eyesight, I did not consider photography important, but now I realise that I have missed many opportunities to preserve memories. Now that I am not able to see, photography helps me to make images and share emotions.*"

In one photograph she has become the cold and shimmering moon in a blue dark sky.

Photographs in this feature are *Untitled*, Mexico, 2012-14

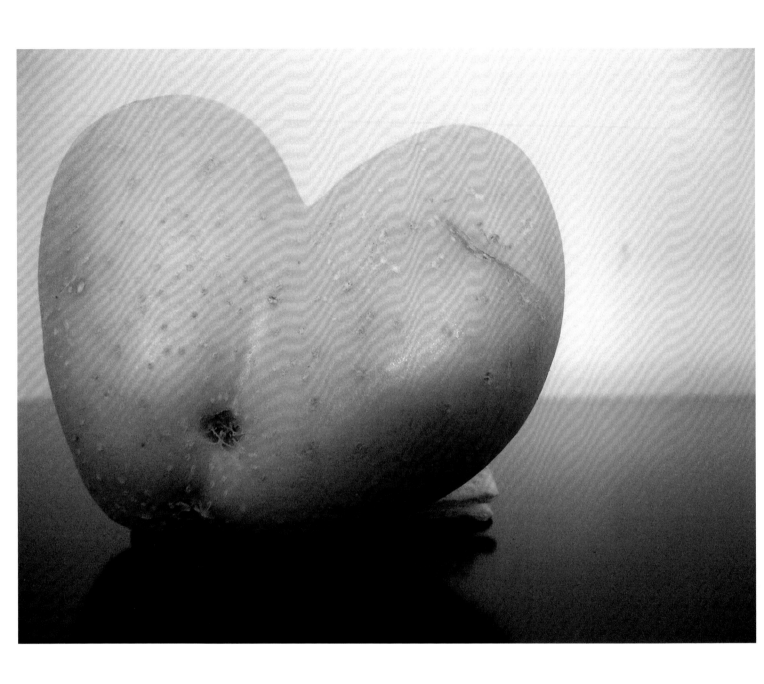

30

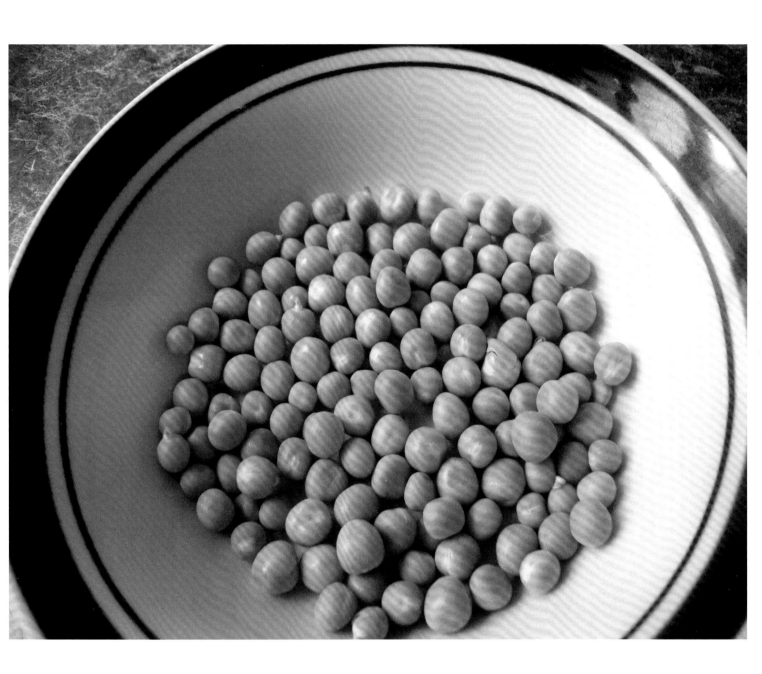

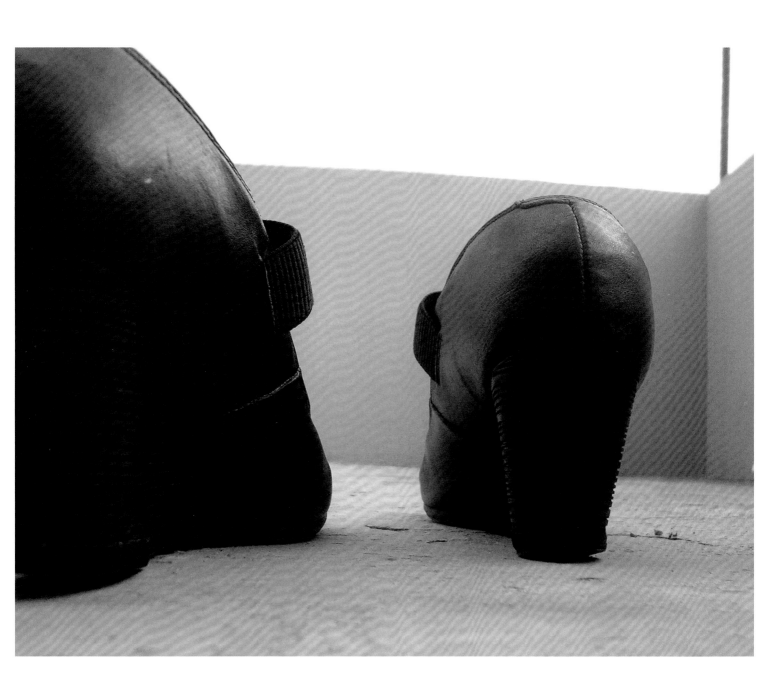

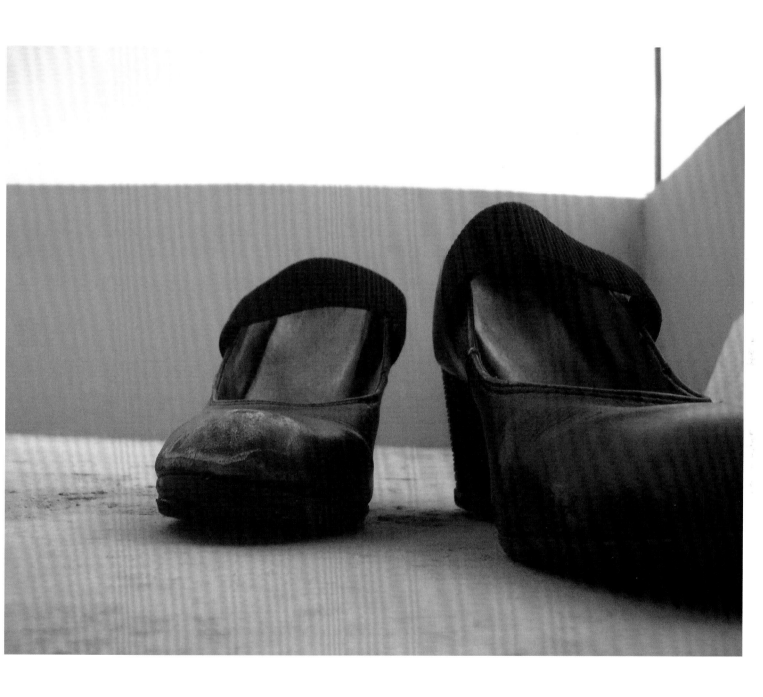

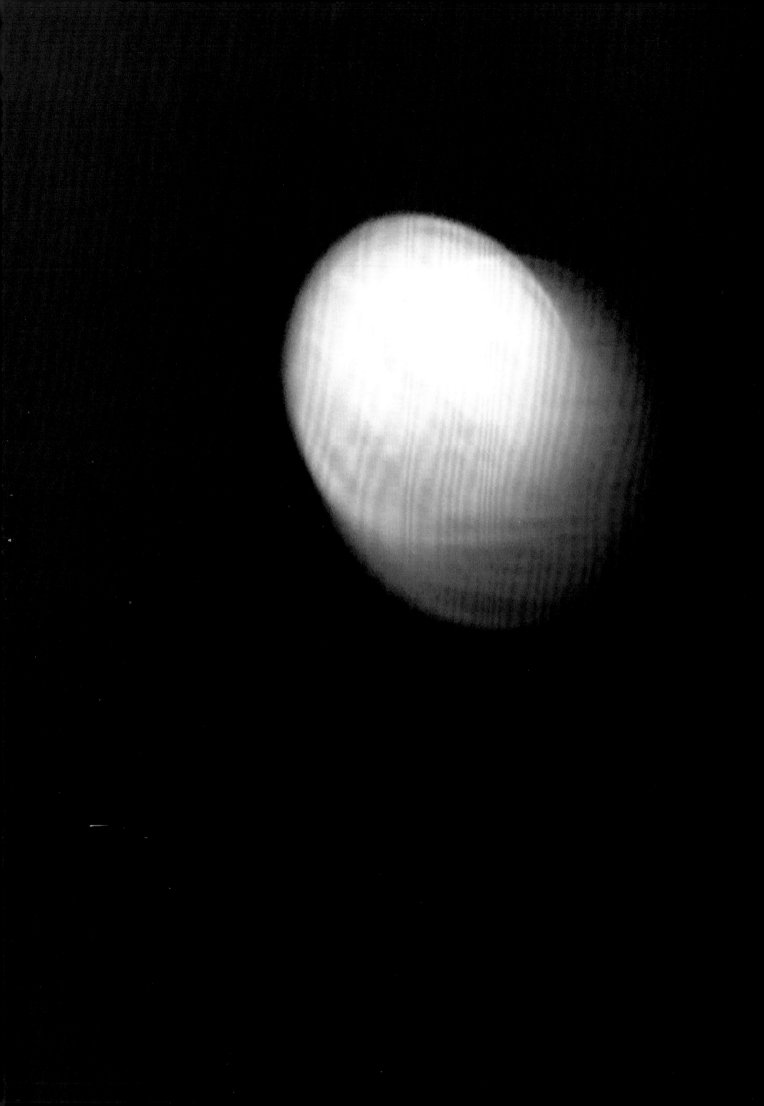

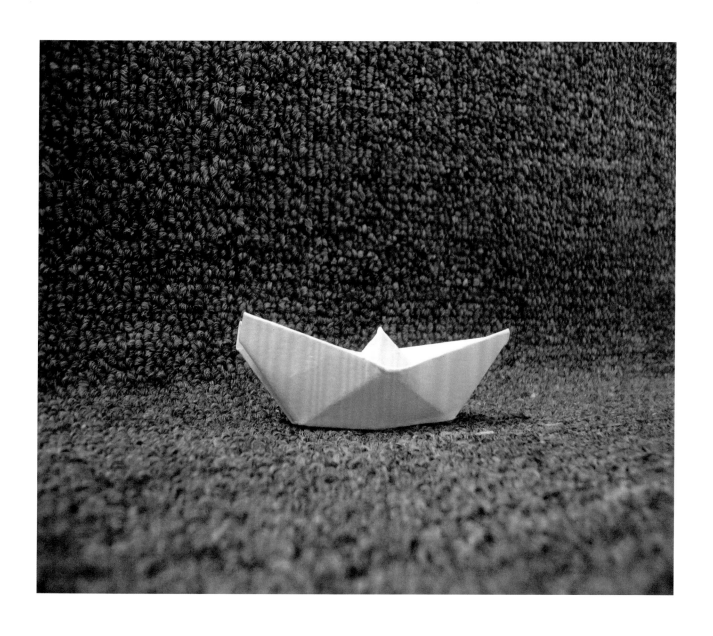

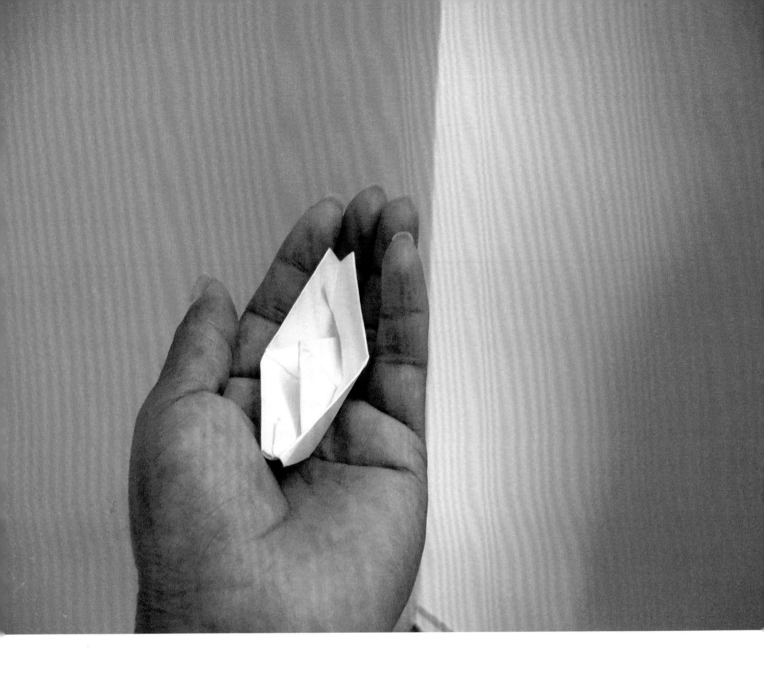

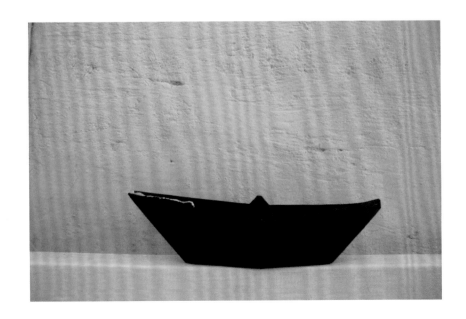

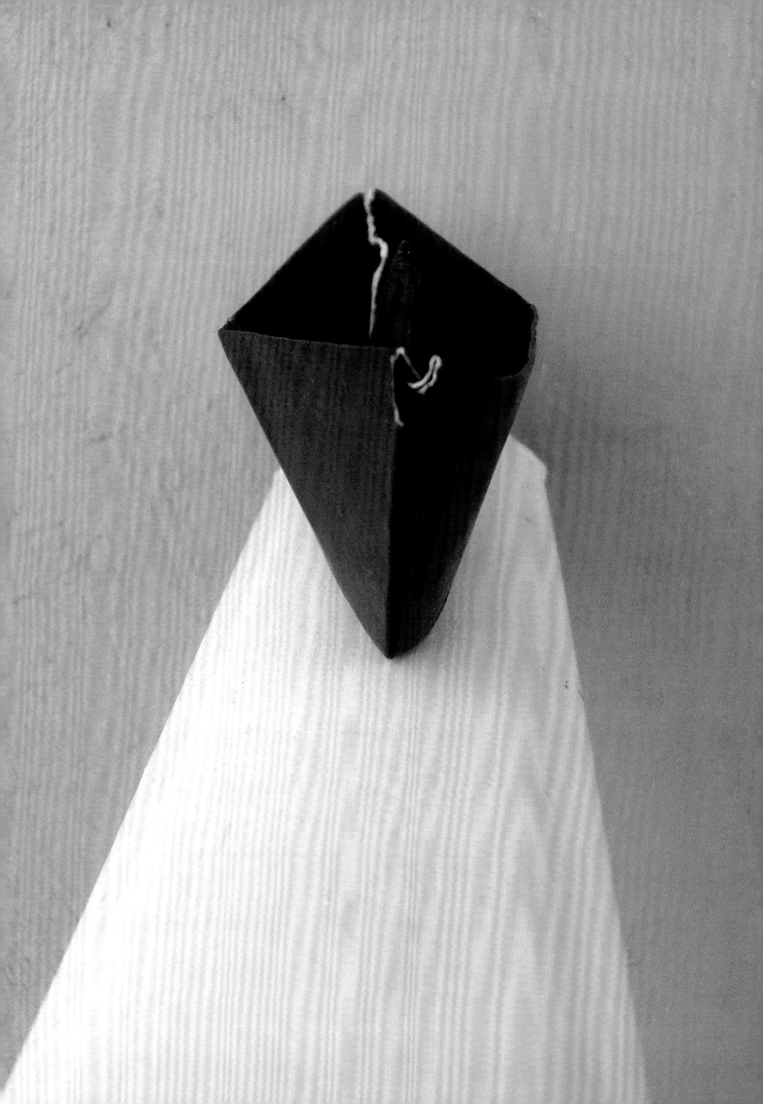

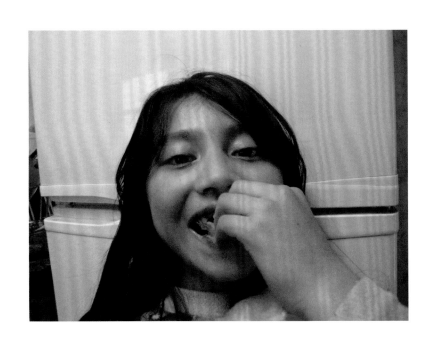

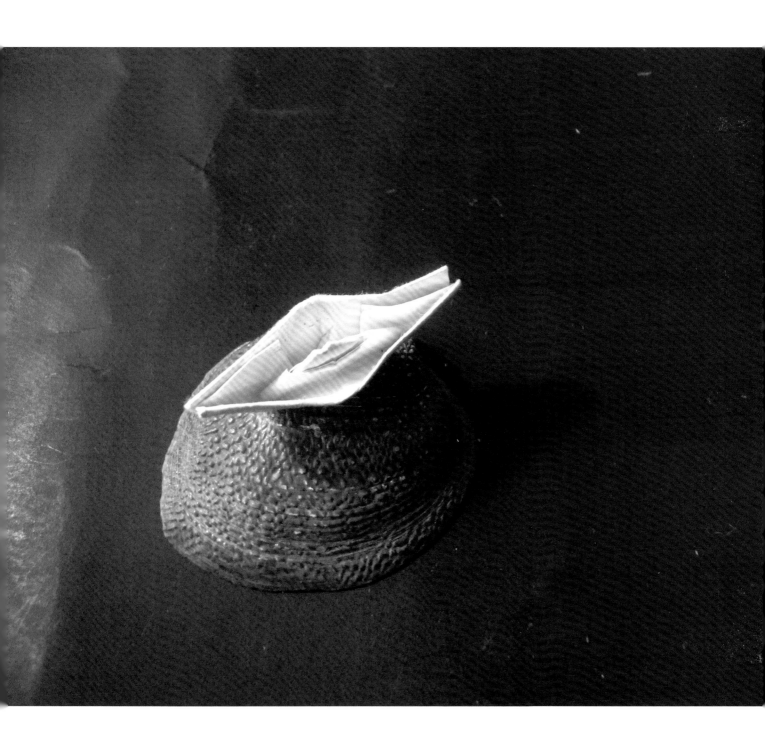

AARÓN RAMOS

"I use my senses–hearing, touch, taste and smell – when taking pictures. When I touch the camera lens I create an imaginary line from the lens to the object I am taking a picture of; I create the picture in my mind, I feel it and construct it to communicate feelings to the normal-visual world."

Aarón Ramos's photographs are allegories. What is seen is what is there as the camera clicks; this is an object or an arrangement of objects set up as determined by the author-photographer. What it 'means' is something else. Aarón Ramos is a conceptual photographer: he sees the image or the sequence of images as presenting certain ideas in pictorial disguise. He speaks for himself and his photographs with great eloquence. When he speaks of his motivations, he hints at a programme.

In the first place, in the mind of the photographer, the image is intended to present symbolic correlatives:

A flower is a symbol of threatened nature: *"The photograph of the blue and purple flower is part of a project called* Magical Nature. *Someone once said to me: 'we are all one and the same' and it was clear to me that if you don't look after what you have and you spoil your environment, you will end up hurting yourself. We must value what we have."*

Insects are creatures caught up, like the blind, in circumstances of sensory deprivation: *"The green caterpillar and the little yellow and black beetle are from the project Unknown Environment. My experience of change and effective adaptation to unknown surroundings led me to create these photographs with living creatures. I placed them in total darkness to simulate sensory experiences similar to mine: I wanted to show the world – and myself – that nothing is impossible in life."*

Photographs in this feature are *Untitled*, Mexico, 2010-15

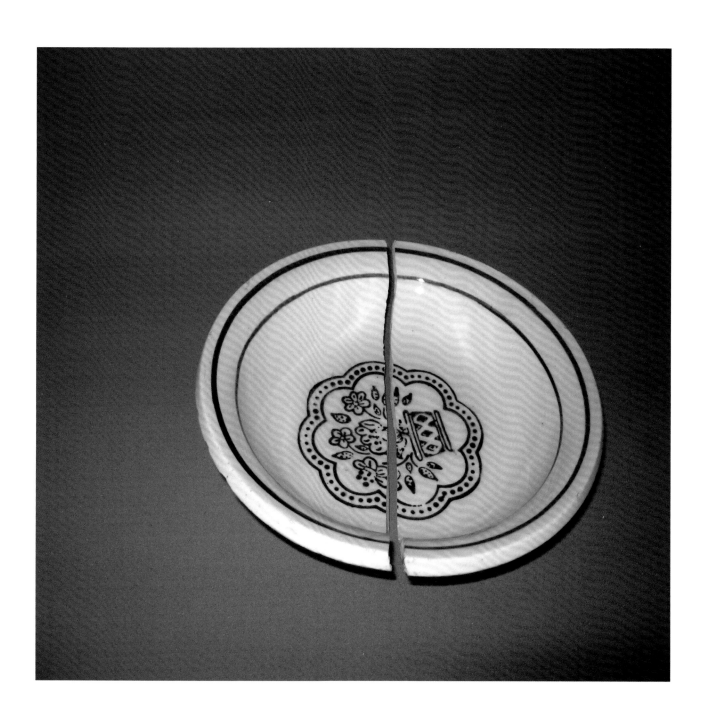

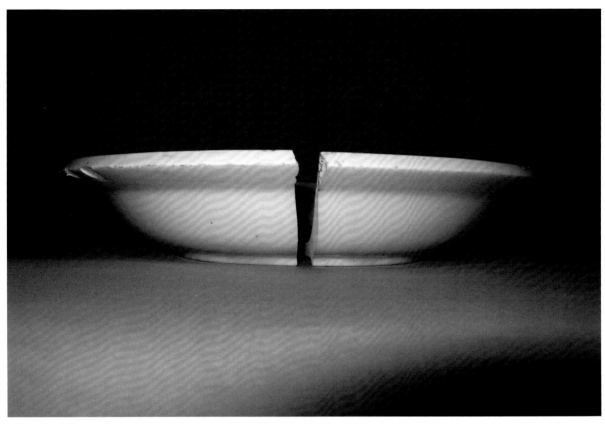

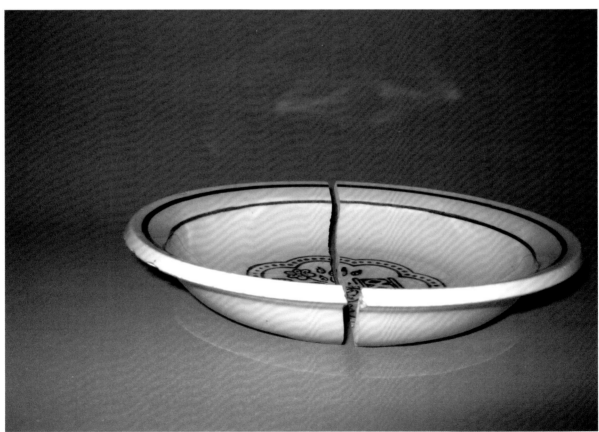

A broken plate is presented as a symbol of the transience of life itself: *"The broken plate series is entitled* The beauty of life in the appearance of dying. *It carries the message that all of us have something to give to the world, even as we are aware that we live in a process that comprehends death."*

A bug declares its tiny presence as a self in the world: *"The green bug with antennae is from* Project Bugs. *Here I am! Do I have to be huge for you to notice my existence?"*

Photography makes such moral fictions possible for all who wish to make art in this way. But, of course, what the spectator makes of the image may be something quite different. Ramos's flowers – a morning glory, a meadow daisy – catch and absorb the sunlight as radiant *selves*, beautiful and transient. Insects in any light are miracles of natural adaptation, fantastic and diverse: Ramos's photographs, paying them such rapt attention, force our attention to their marvellous singularities. Ramos's broken plates portray the divided self, integrity fractured; a sequence finds the separated pieces dancing in their red ballroom, partners seeking perfect unity. The image of the broken plates is a metaphor capable of double readings: of lost unity and rupture; of Plato's perfect circle seeking its completion; of despair and hope. Ramos's concentrated formalities of presentation declare these allegories.

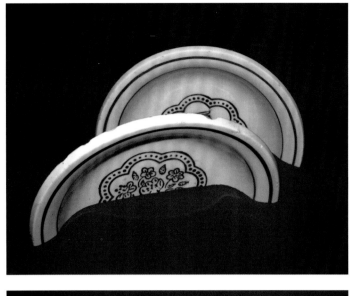 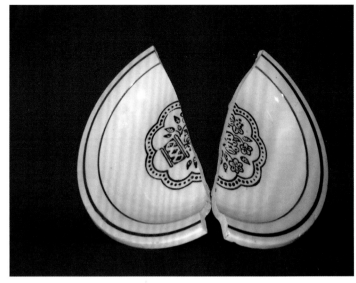

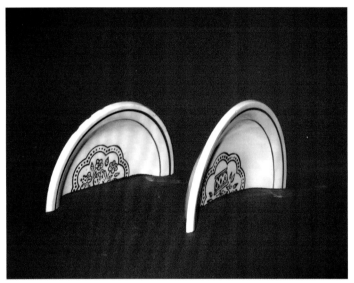 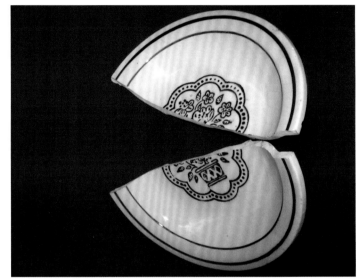

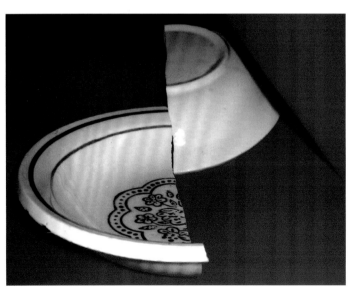 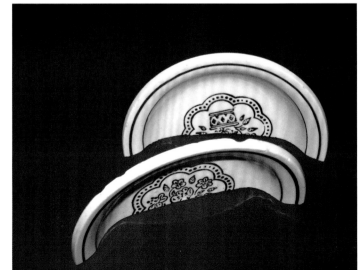

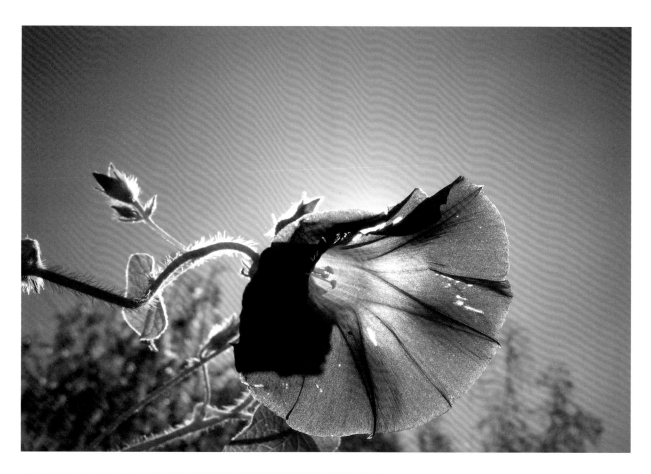

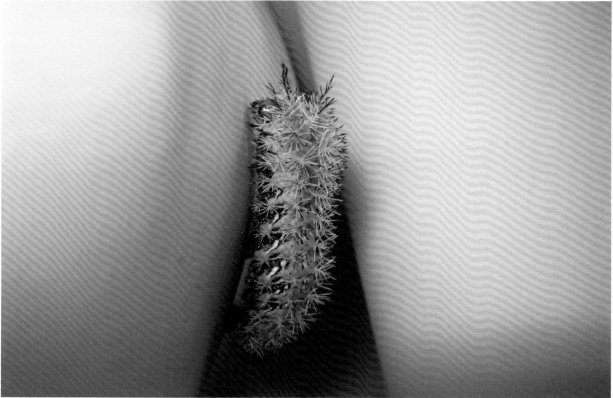

Ramos's snail on a cracked tree stump is a masterpiece. That shell has grown in spiral form, the tree over a much longer time, by the development and eventual death of successive rings of growth. The organism within the shell has died; the tree is now dead, and its rings speak of its successive years of life and of death within the growing organism. The image is then a complex *memento mori*.

"This photo was taken one day that I decided to take photos of insects, and while looking for them accompanied by a friend who could see, we found this, of which my friend said: that is empty, you won't like it. I said: this is exactly what I was looking for, something that once had life inside it, and which now is empty." Two time-scales of life, two principles of outward growth; two beautiful, natural things: two living things now moribund.

"The empty shell is called Interrupted Process. *I am trying to capture and preserve for eternity the image of certain dead creatures, as if trying to extend their life in this world."*

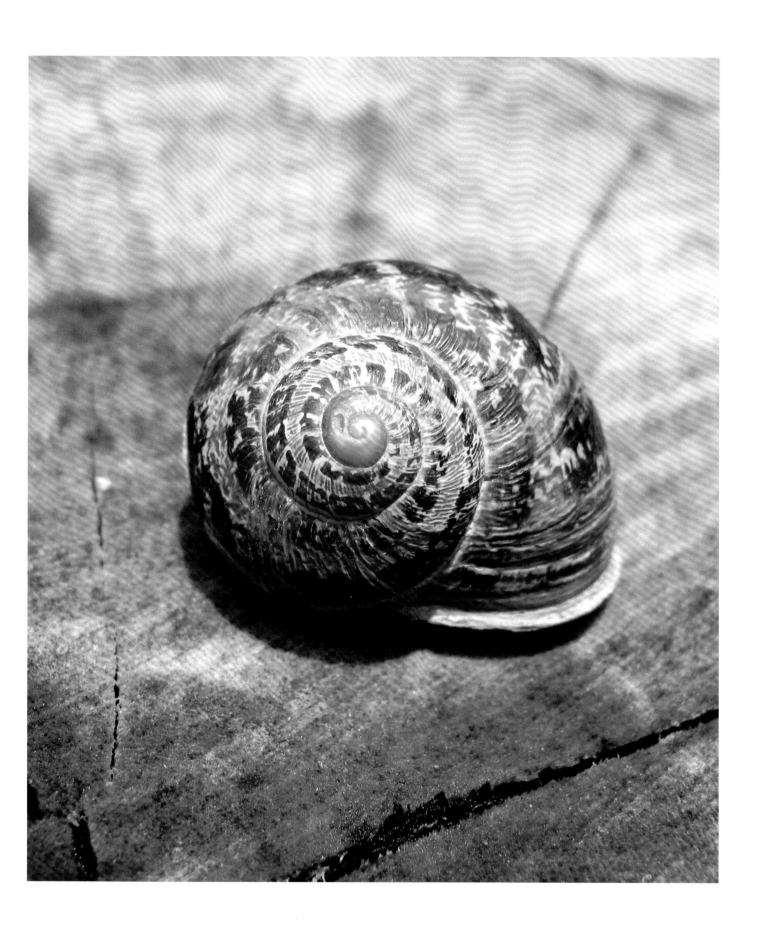

'*The toys photograph is called* Silent in Solitude. *When I started to accommodate myself to my visual impairment I had to separate from my children. One day after school, I went into the room where my children used to play. I walked around the room and touched some of the toys with my feet. I was surprised that they made a sound as if to say that they had been abandoned and left silent in their solitude.*'

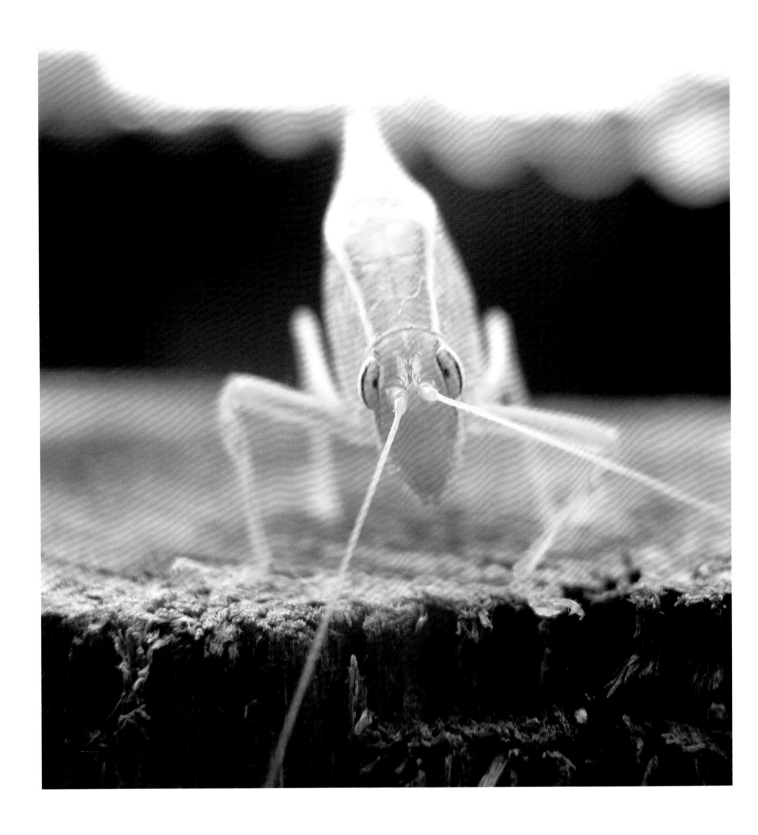

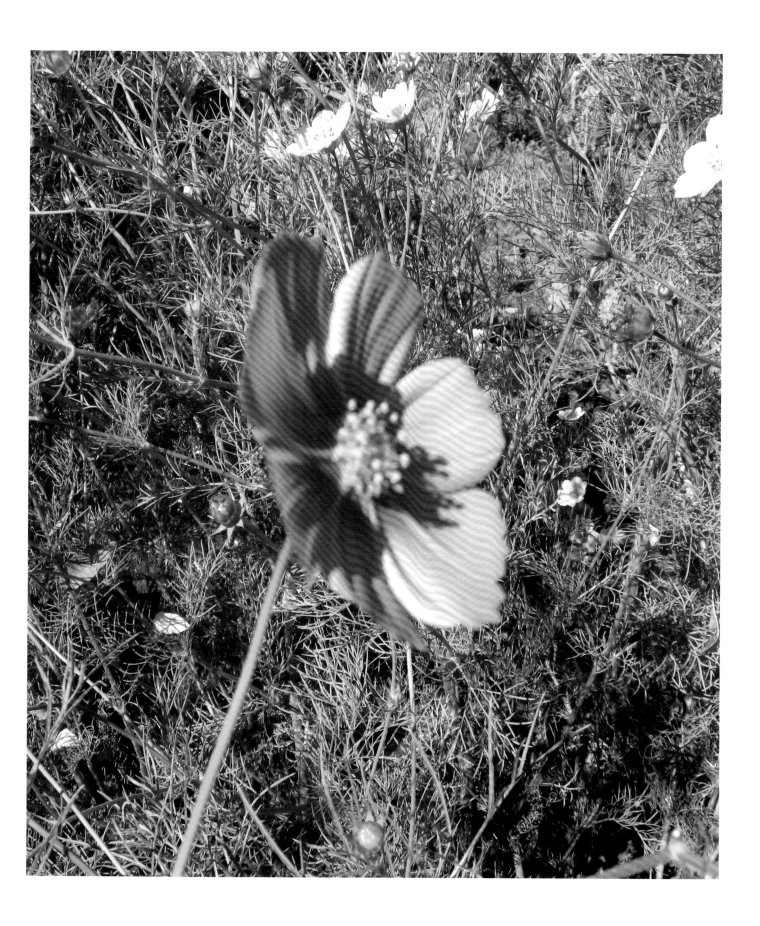

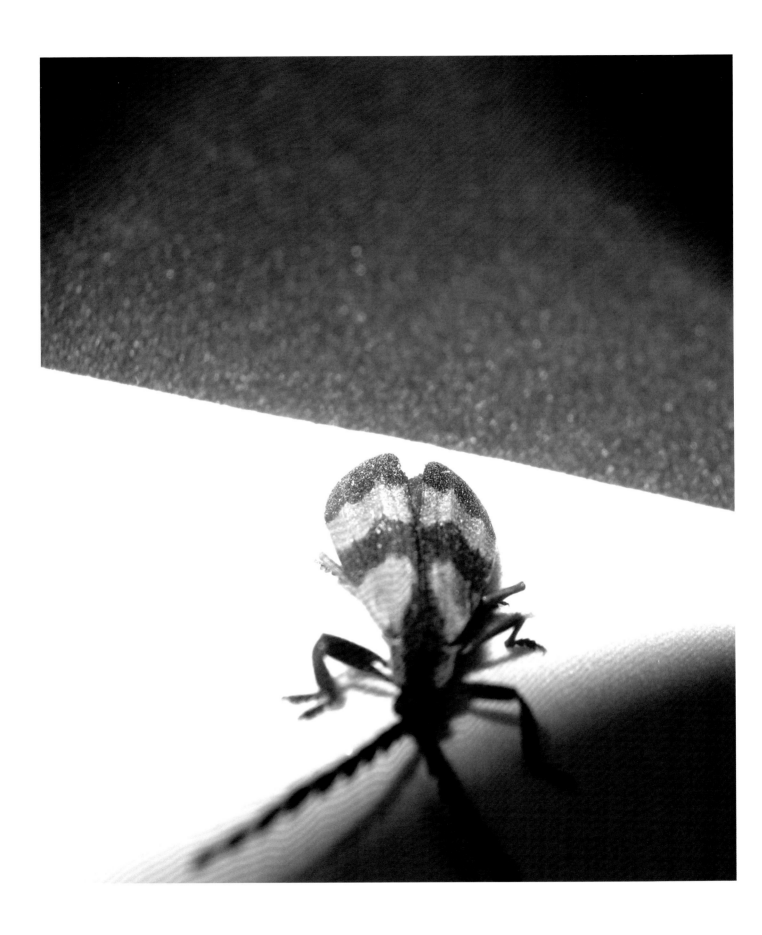

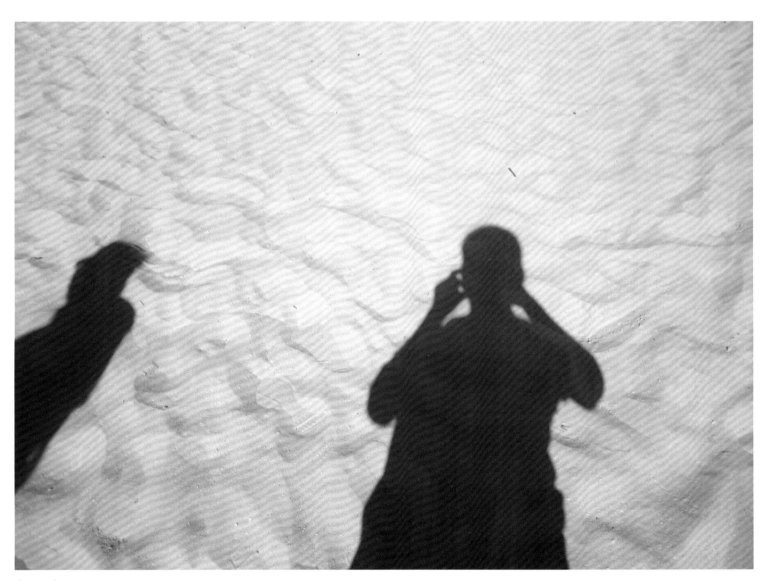

Édgar Ángeles, *Untitled*, Mexico, 2010

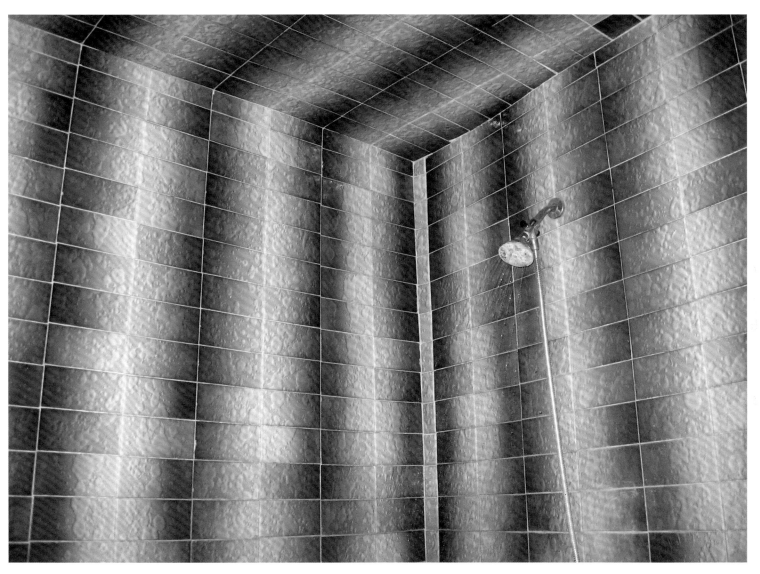

Ana Soriano, *Untitled*, Mexico, 2010

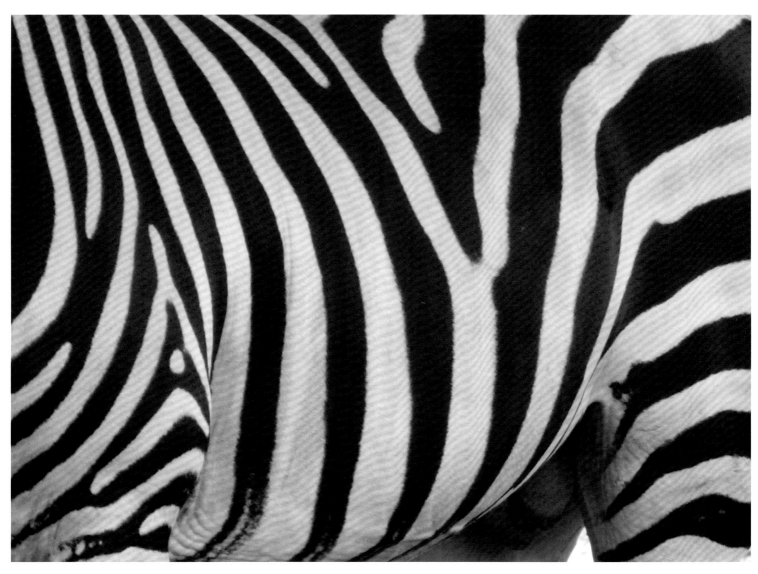

Miguel Fabián, *Untitled*, Mexico, 2013

"*Astonish me!*" said the jaded fabled impresario. Miguel Fabián has been astonished: he knows of the fantastic drama of the zebra's stripes, the chromatic brilliance of the scarlet macaw: he reactivates our astonishment.

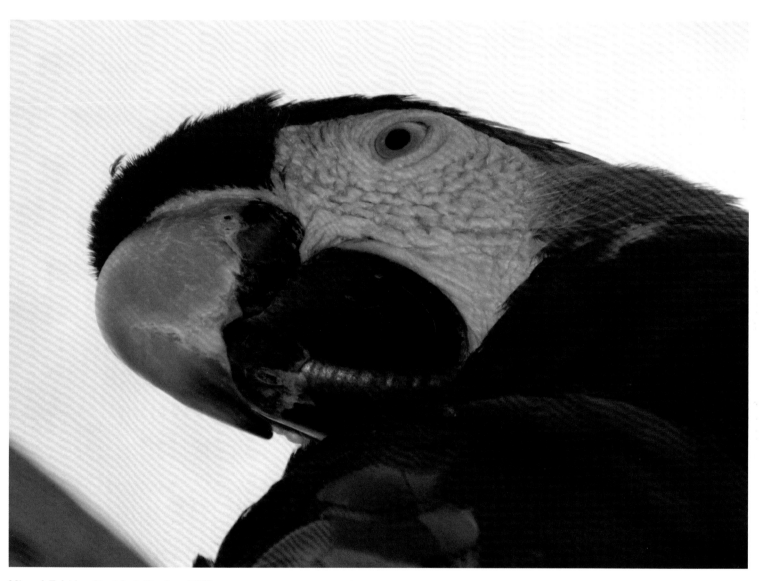

Miguel Fabián, *Untitled*, Mexico, 2013

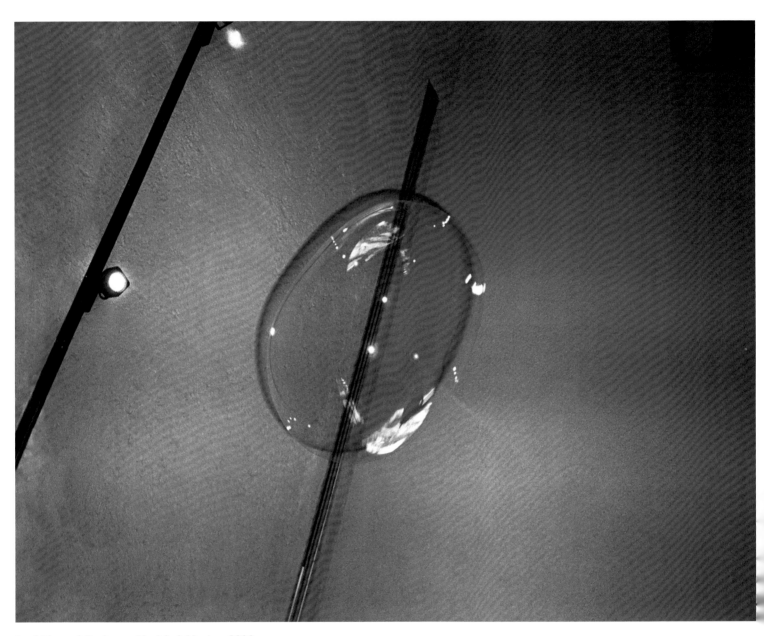

José Manuel Pacheco, *Untitled*, Mexico, 2006

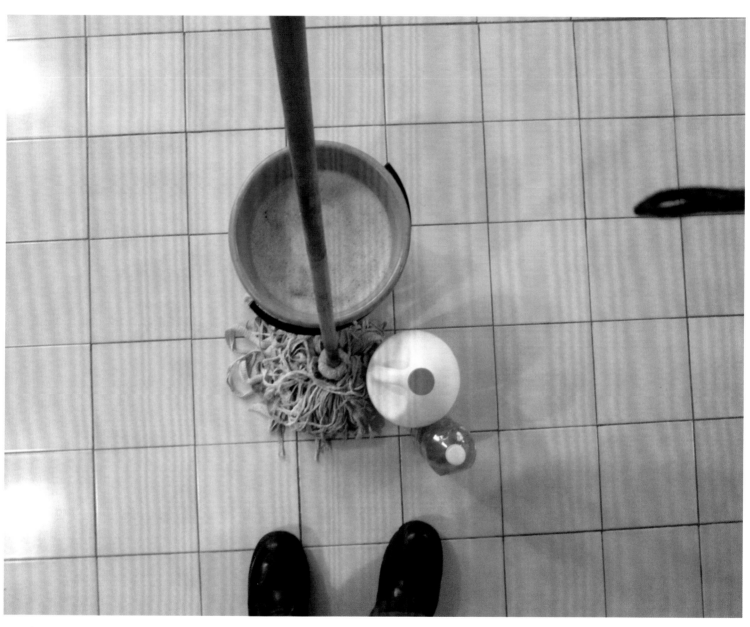

Ramón Jiménez, *Untitled*, Mexico, 2012

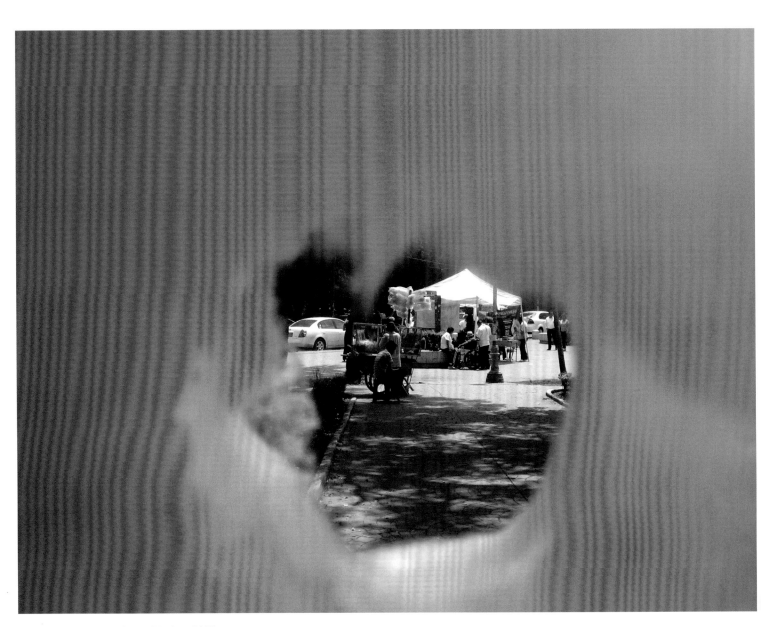

Axel Villalba, *Street Scene*, Mexico, 2010

Hilda Barrera, *Untitled*, Mexico, 2010

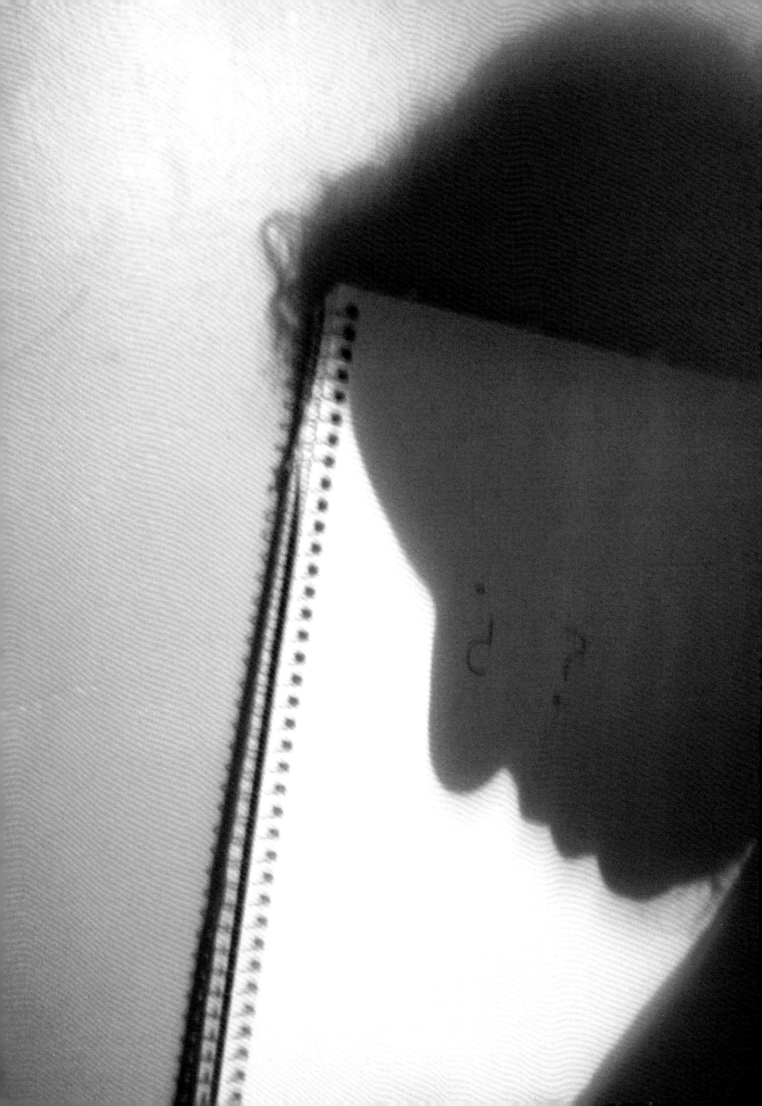

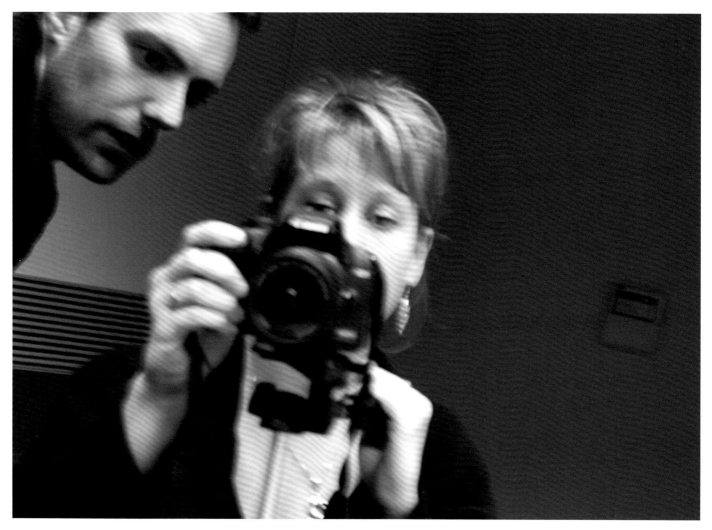

Mickel Smithen, *Tanvir Bush with Matt Larsen-Daw of Photovoice*, UK, 2009

TANVIR BUSH

The beauty of concentration: the beauty of anticipation,
the beauty of inward observation. Empathy (see Marco
Antonio Martínez's photograph on page 107)

Photographs in this feature are *Untitled*, UK, 2009

The joy of a simple physical act, of an act of demonstration, of an exertion; of being *caught* in the act (sewing, a symbolic dance); eyes that always acknowledge the presence of the recorder, the photographer herself: these are the subjects of Tanvir Bush's concentrated art, an art of determined anticipations, of the seen knowing they are being seen (even as through a glass darkly).

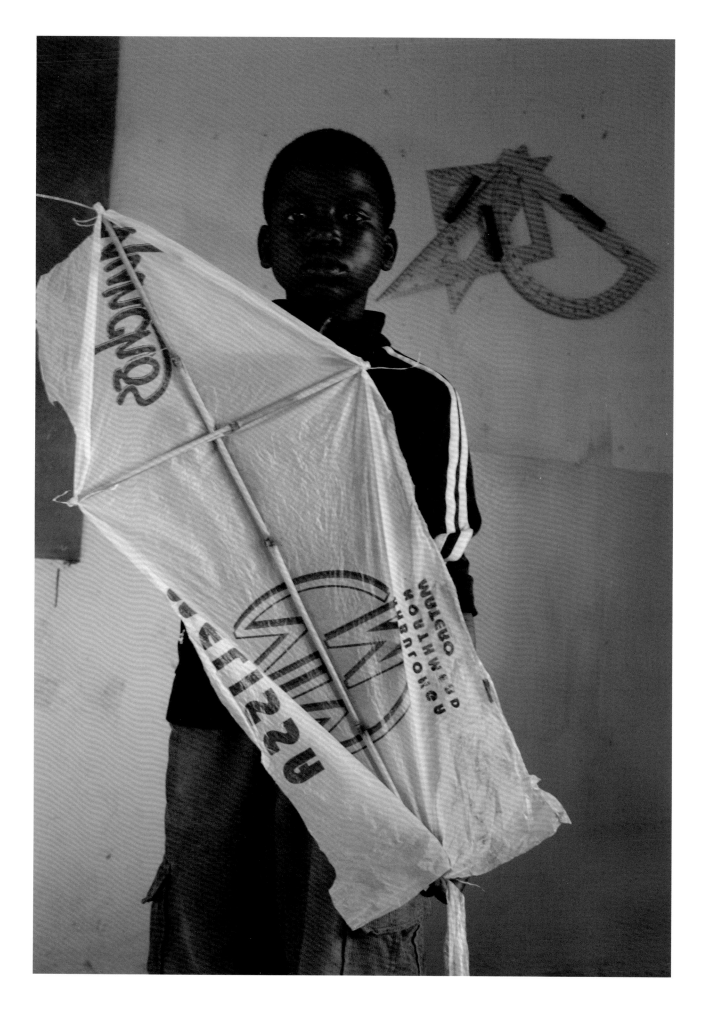

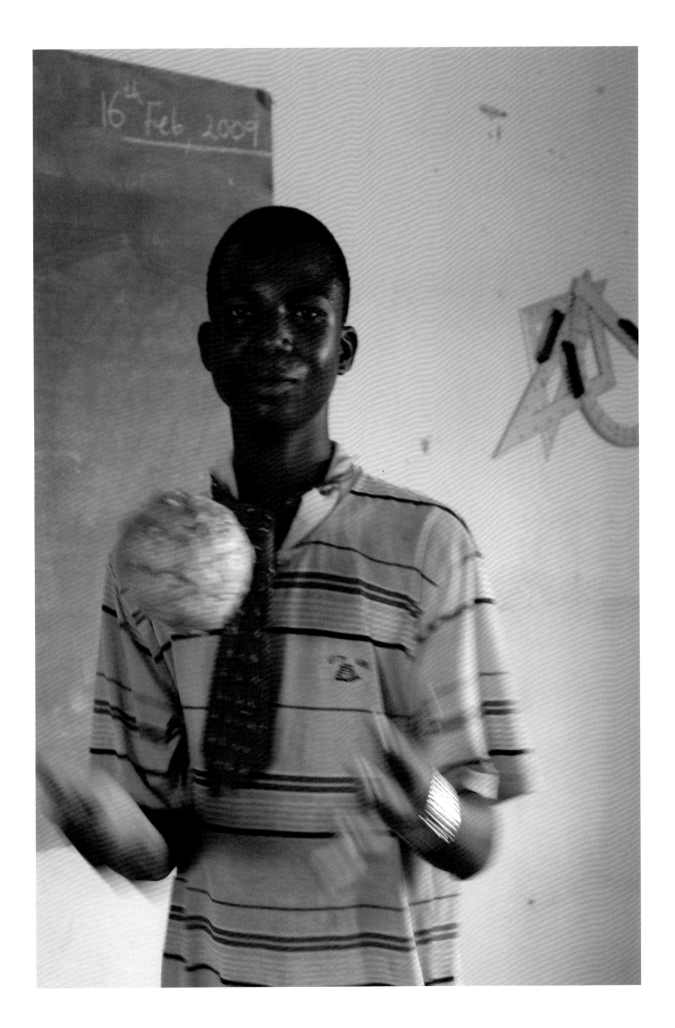

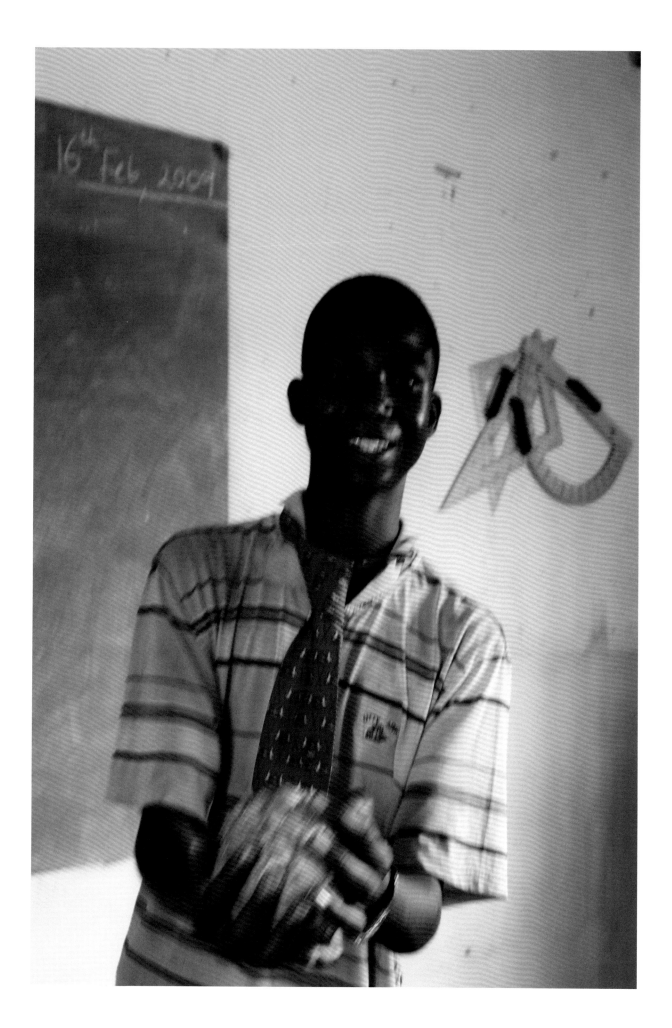

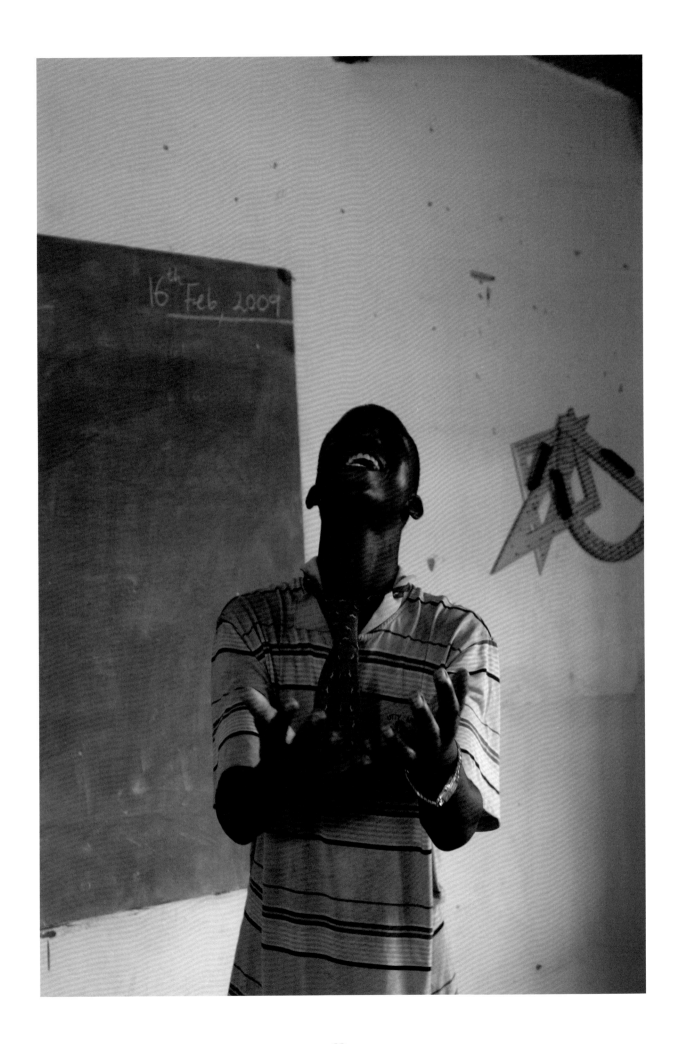

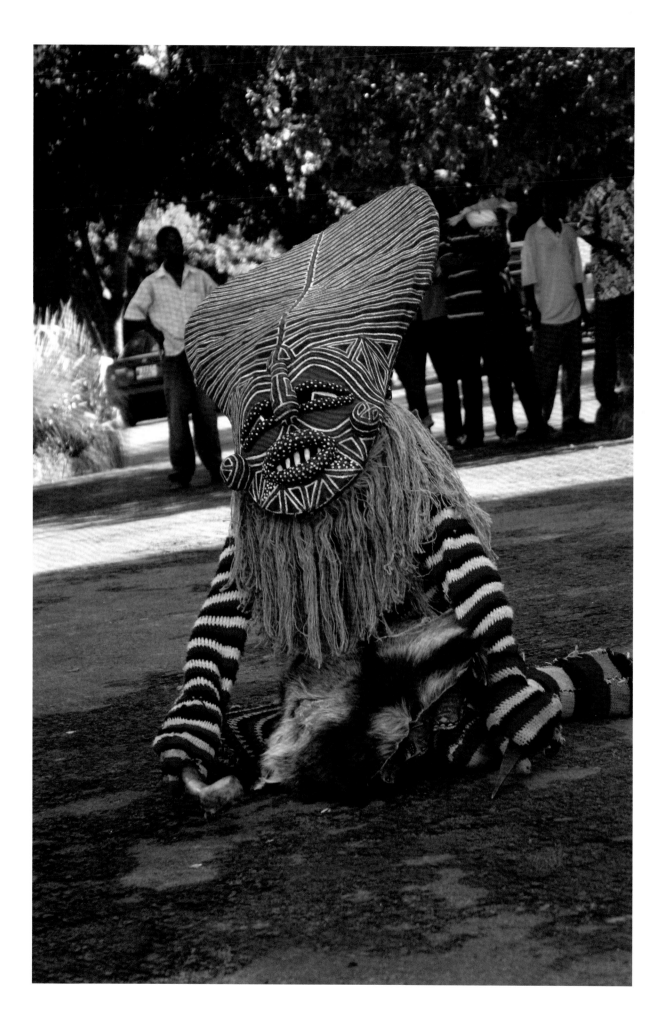

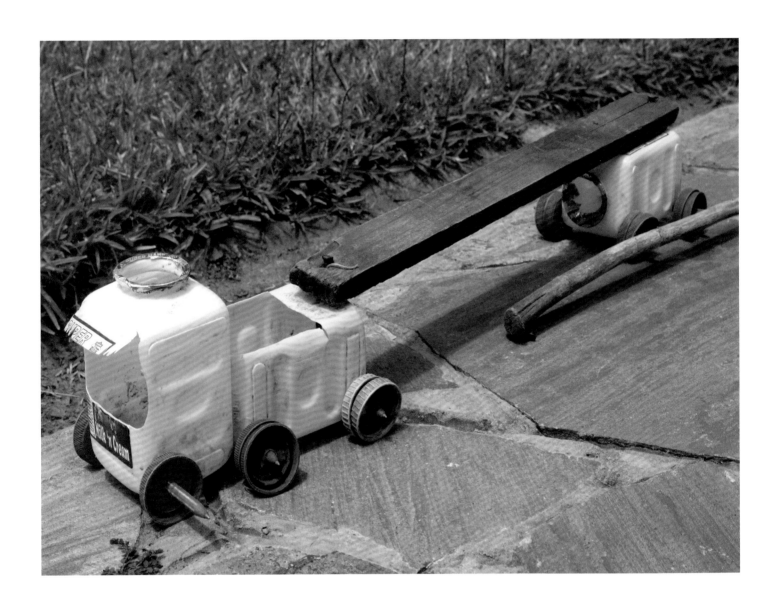

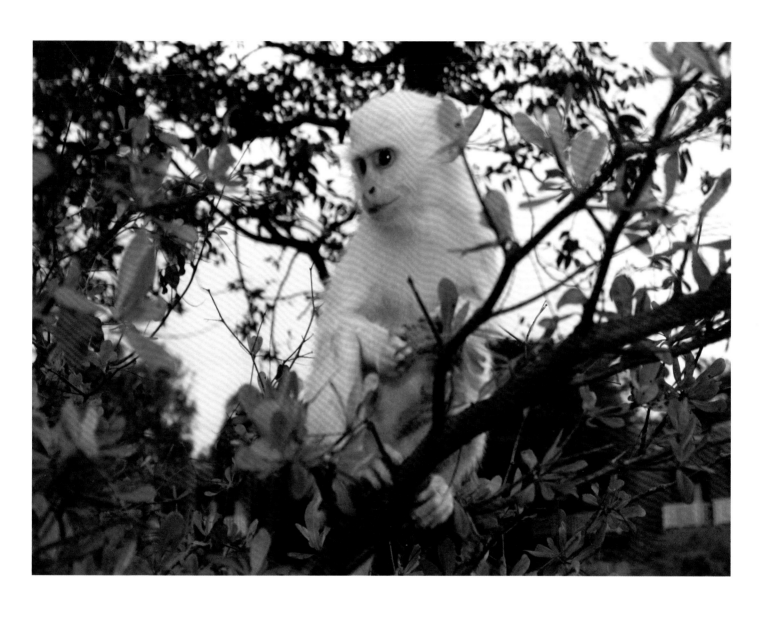

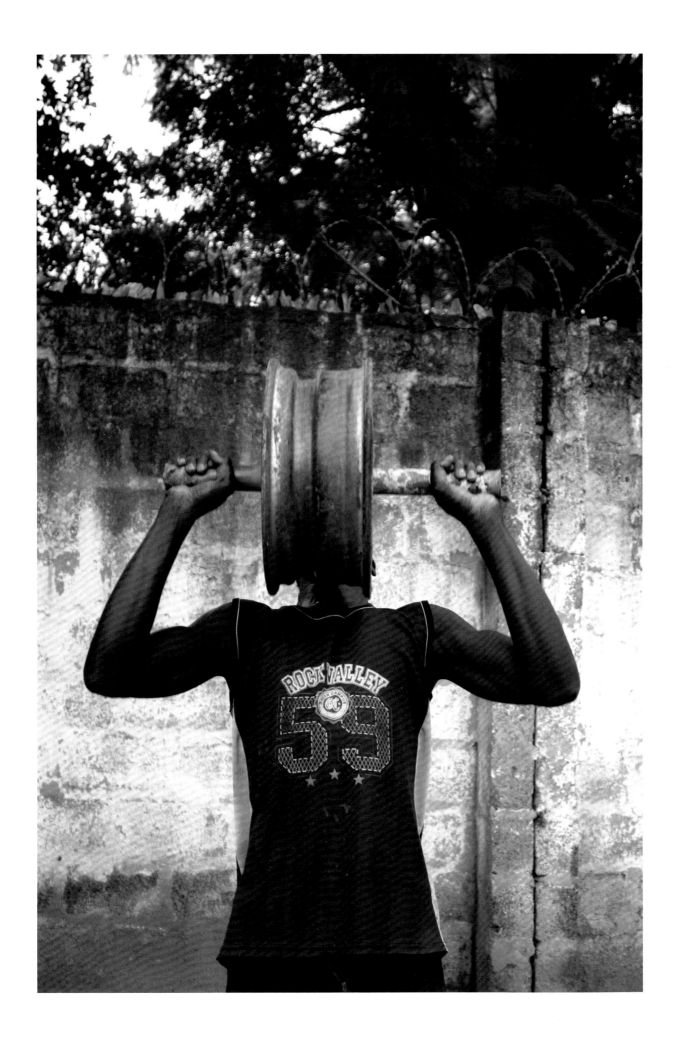

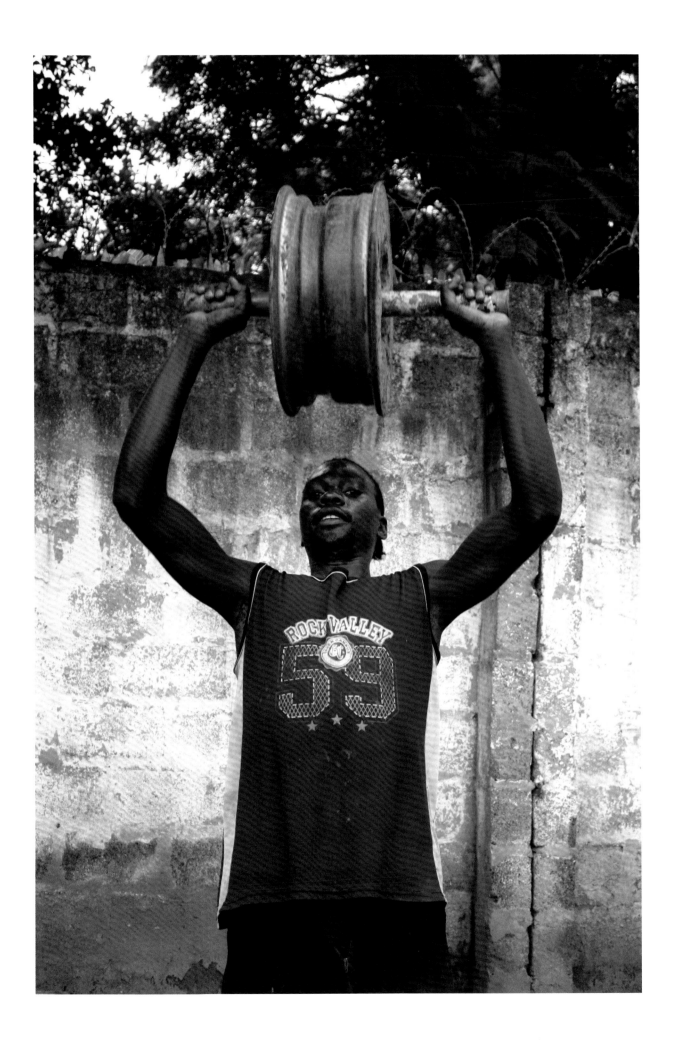

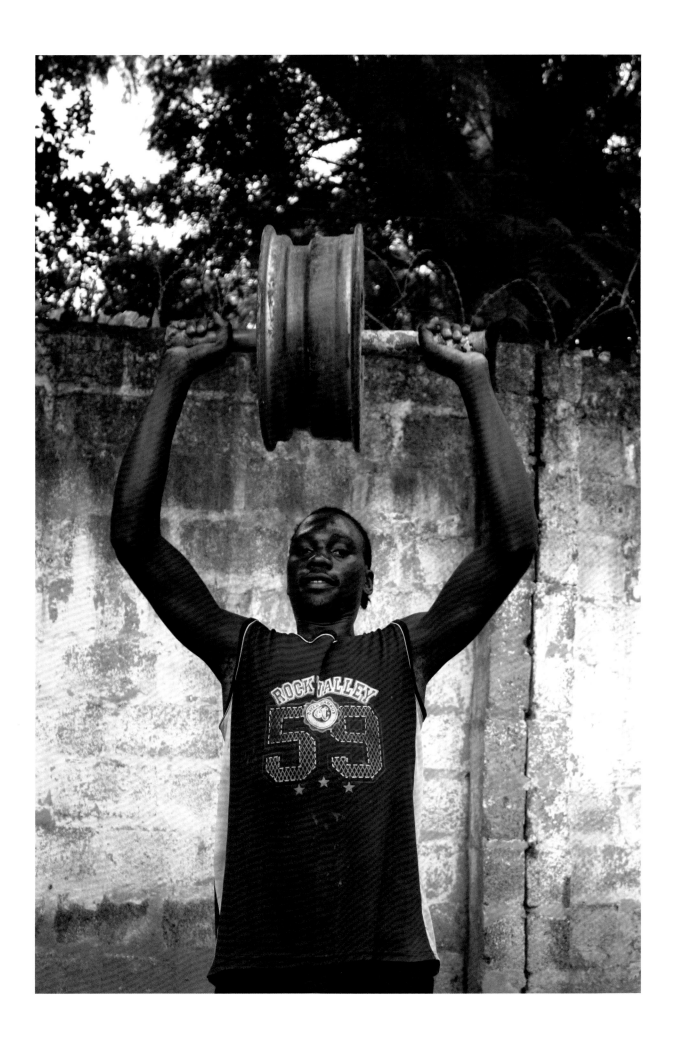

PEDRO RUBÉN REYNOSO

Pedro Reynoso's sweet-smelling fruits! The feel of the textures of their skin, their shapes: the coarseness of *orange*, *grapefruit* and *lemon*; smooth hard, smooth soft: hard-sphere-*apple* and soft-sphere-*plum*; irregular ridge-edge of Yucatan's *carambola*, *starfruit*; soft-sea-urchin *rambutan*, its *lychee*-like heart; the hardness of the *pomegranate* with its strange protuberant crown, split, its pithy compartments of spilling seeds; the knobbled elliptical *prickly pear*; furry *kiwi*; velvet *apricot*; coarse *cantaloupe*; smooth swelling sexy *mango*; rotundity of *watermelon*, cut, its cold-watery sponge-like flesh and pips pleasant to spit; prickliness of *pineapple* skin, its wondrous geometry, its harsh hard-needled leaves; sweet pungency of ripe *papaya*; fibrous ribbed and ringed *sugar cane*; diversity of *berries*, soft tenderness of *raspberry*, neat surface seediness of *strawberry*; plenitude in the fingers of twigged *currants*; ponderous clustering of *grapes*; etc. etc. And the strangeness of their meeting with their inanimate opposites, unyielding bowl and basket, porcelain and glass.

Each fruit a delicious miraculous presence and certitude, its self-declarative beingness, bigness or smallness, its spectacular love of fruity company, its absoluteness. How often the blind photographer offers this beauty and strangeness – this light and these colours, these textures, this familiar living rounded diversity of otherness, to the sighted: signs of sensational knowledge, unforbidden fruit!

Photographs in this feature are *Untitled*, Mexico, 2012-13

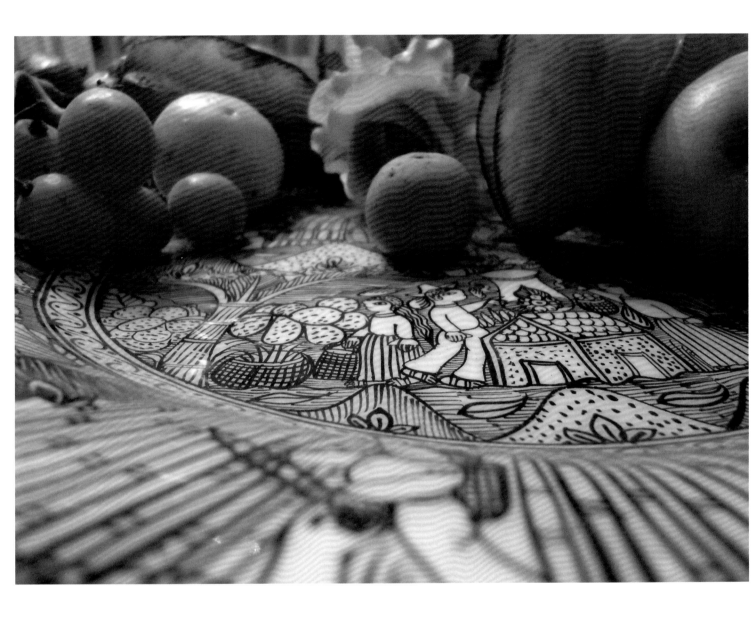

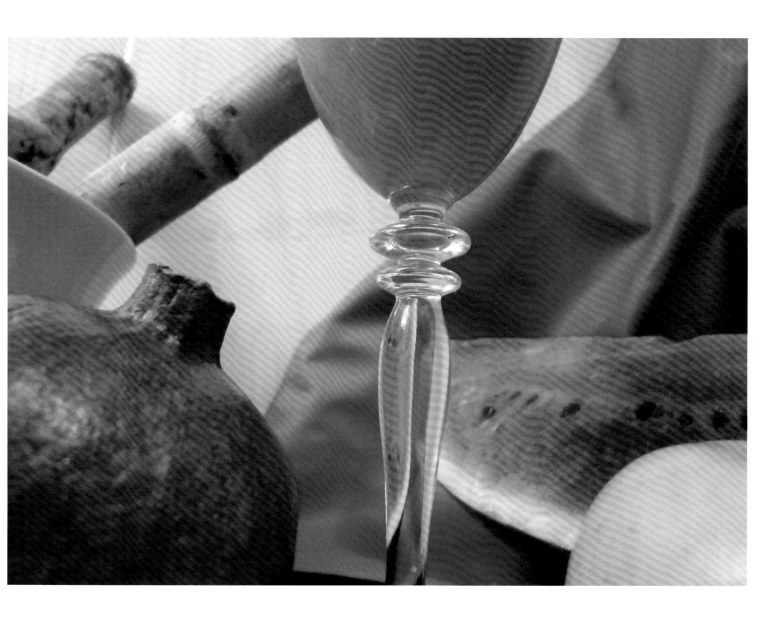

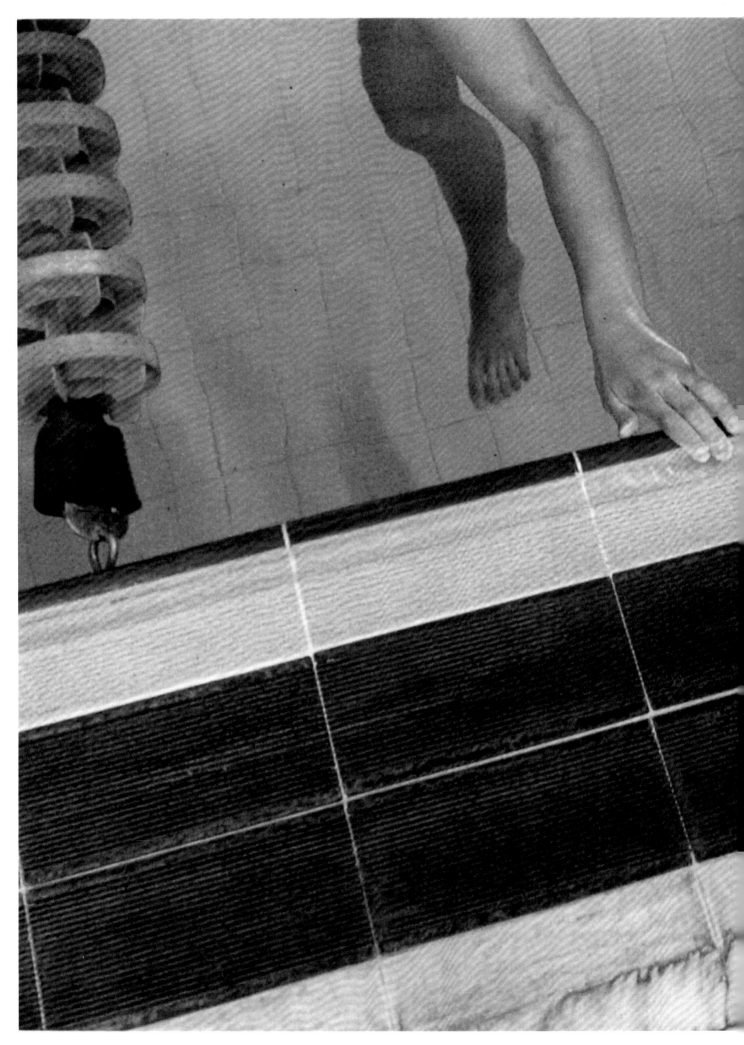

Berenice Hernández, *Untitled*, Mexico, 2011

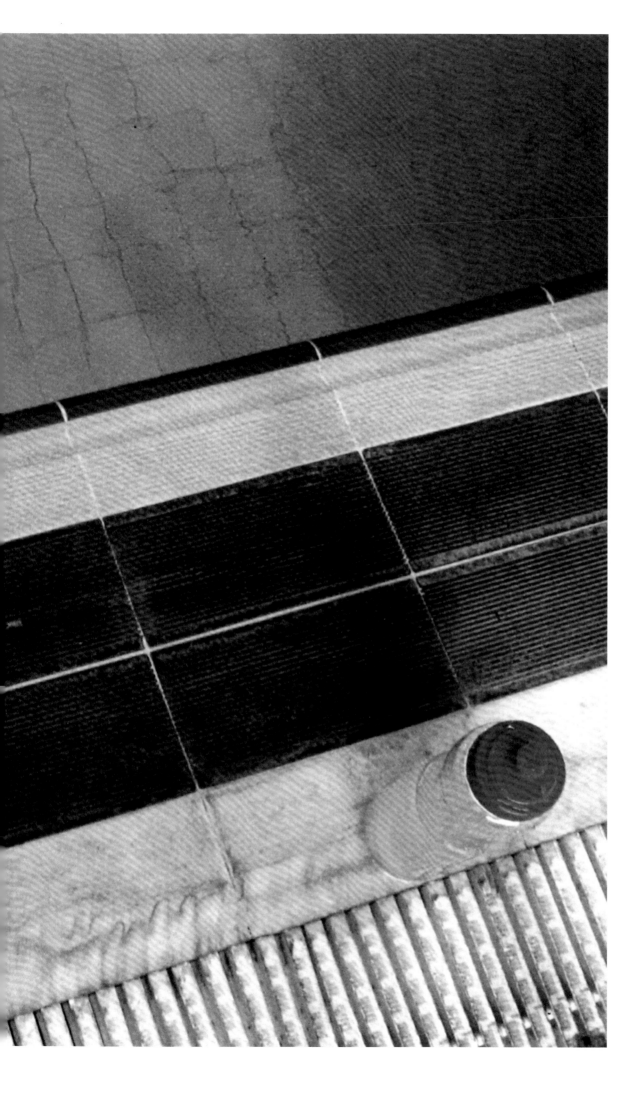

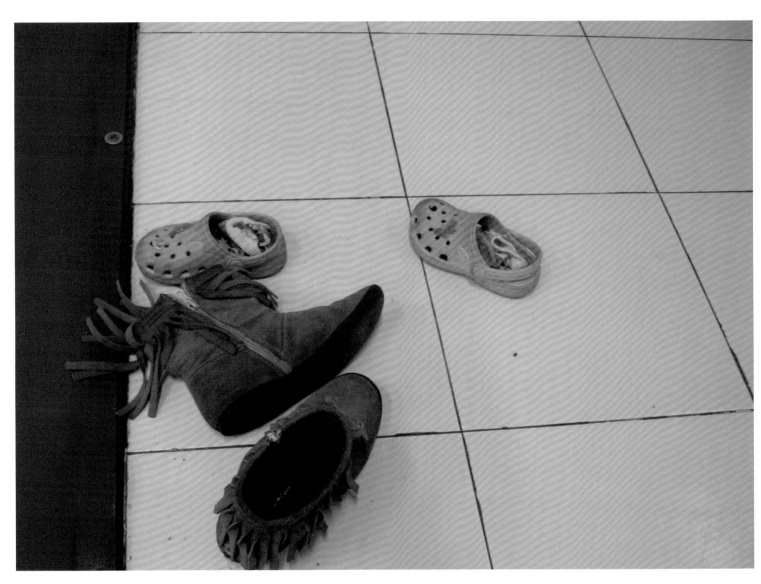

Ana María Fernández, *Untitled*, Mexico, 2012

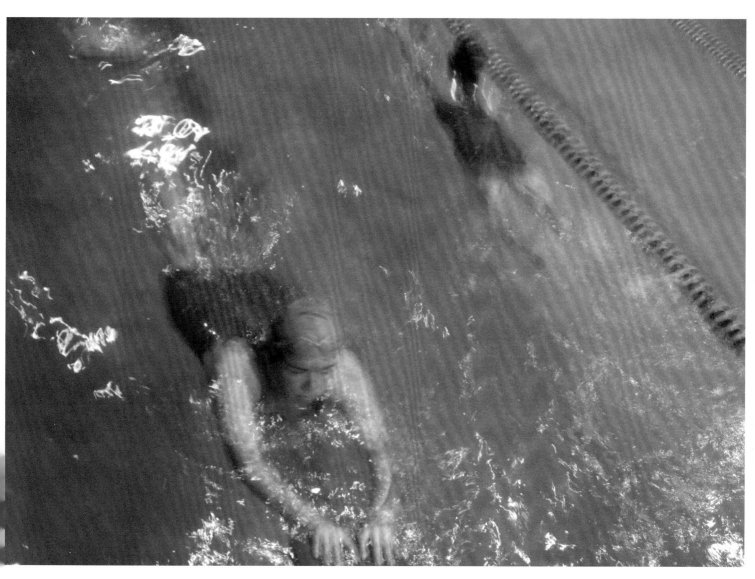

Palmira Martínez, *Untitled*, Mexico, 2012

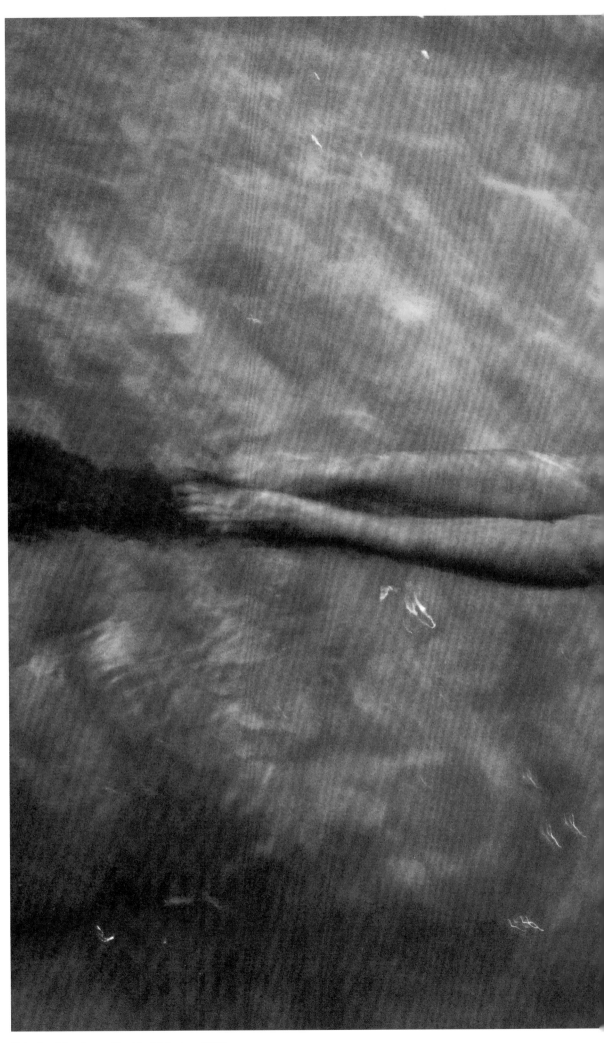

Palmira Martínez, *Untitled*, Mexico, 2012

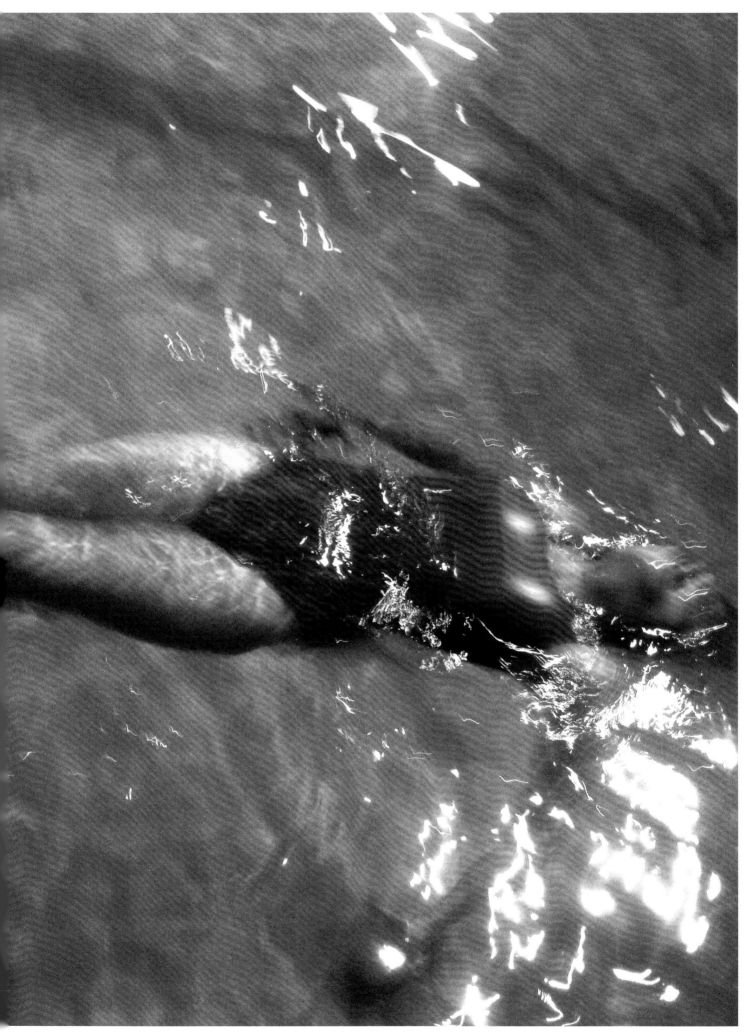

Alberto Loranca, *Untitled*, Mexico, 2011

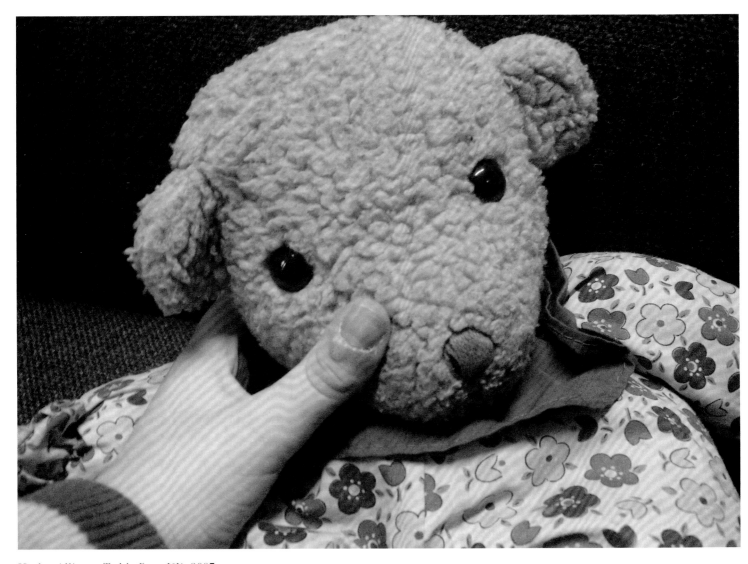

Harley Allison, *Teddy Bear*, UK, 2007

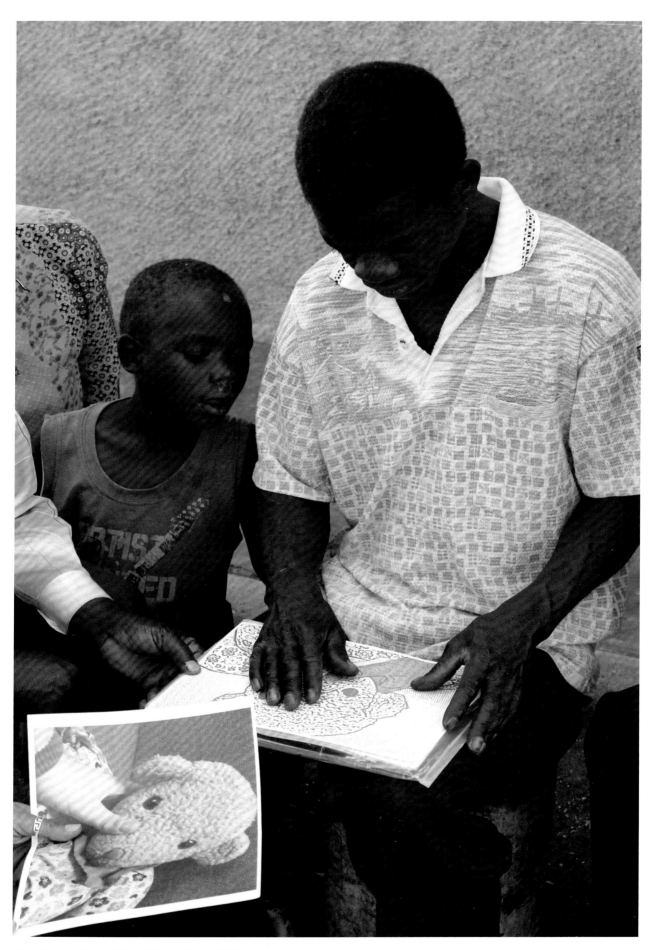

Matt Larsen-Daw, *Jaime, Mozambique*, 2006

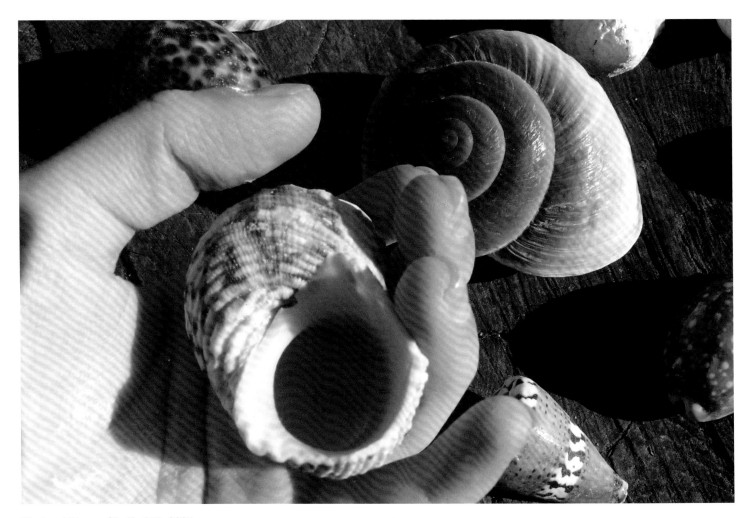

Harley Allison, *Shells*, UK, 2007

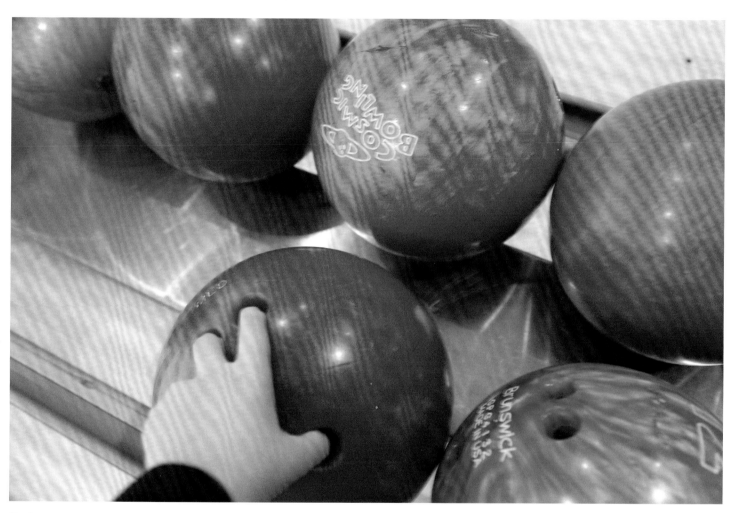

Harley Allison, *Bowls*, UK, 2007

MICKEL SMITHEN

Mickel Smithen is a dancer. He views the world as a dancer. He senses space as a dancer. He relates to others, and to the objects in their space – pavements, walls, stage, curtains – and to the camera, as a dancer. His photography is an extension of his dancing. In his visions the figures on the street, the seated figures, the dancers in the makeshift studio, are all alike caught in the rhythms or stillness of being, composed, momentary, posing, gesturing, moving, dancing: the body as expressive as the face. The very act and image of being *in* the world, *of* the world, *transforming* the world, as definitive, as marking time, demarking space, as making presence felt as aliveness: breathing, posing, *dancing*!

Photographs in this feature are *Untitled*, UK, 2009

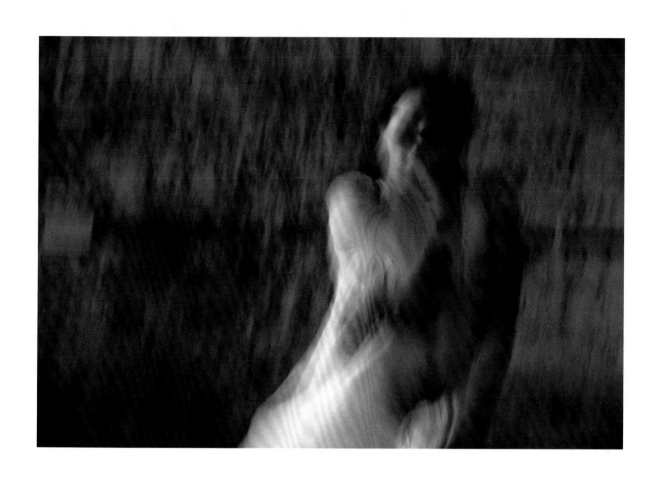

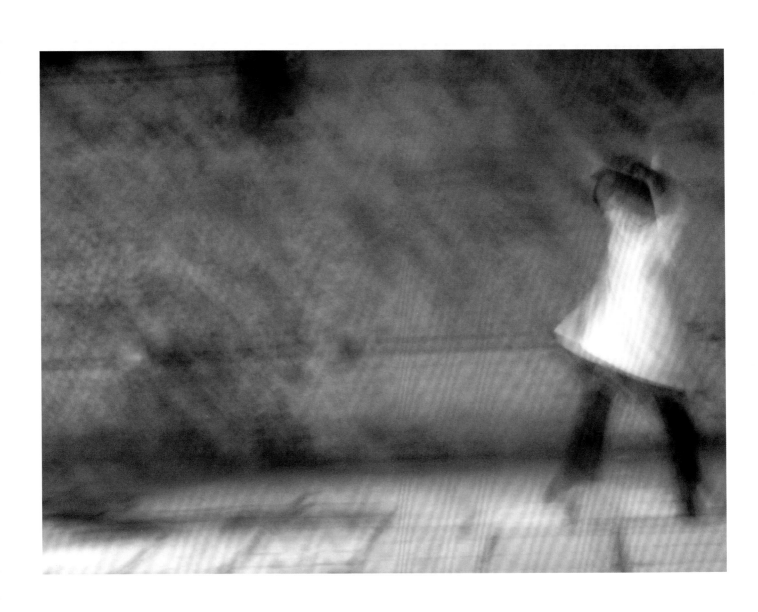

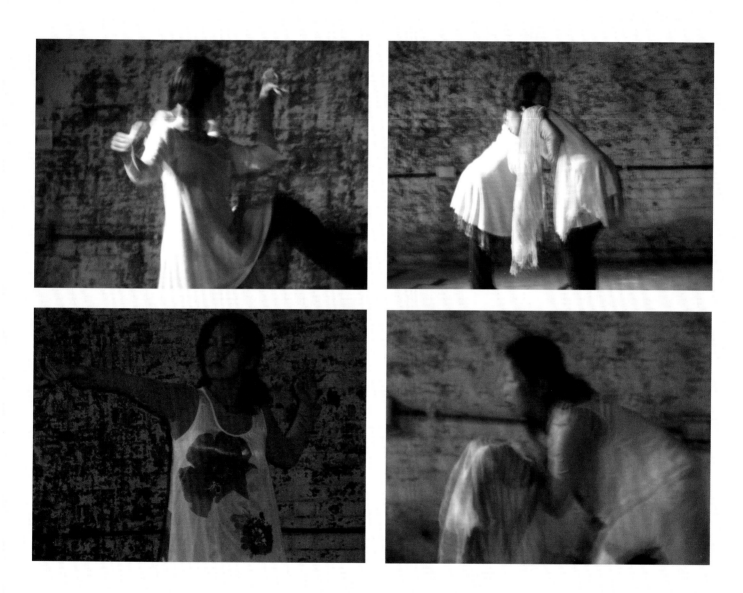

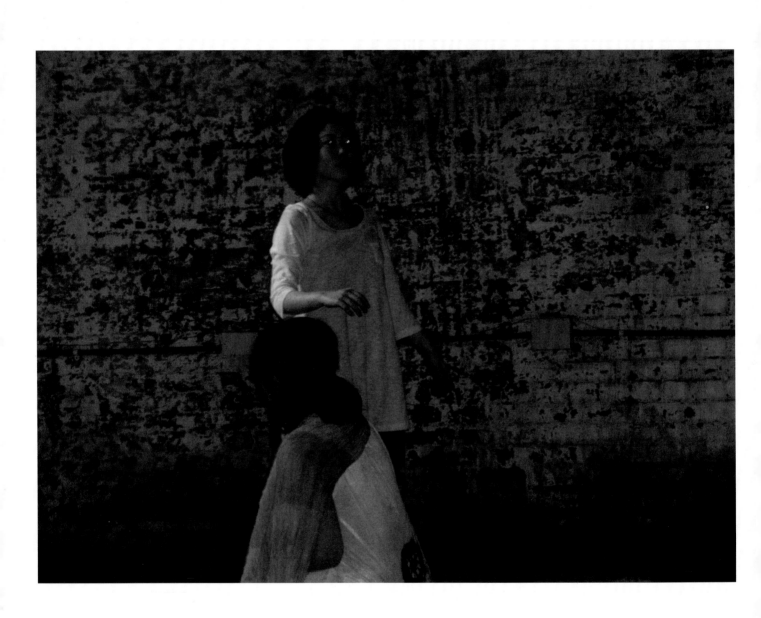

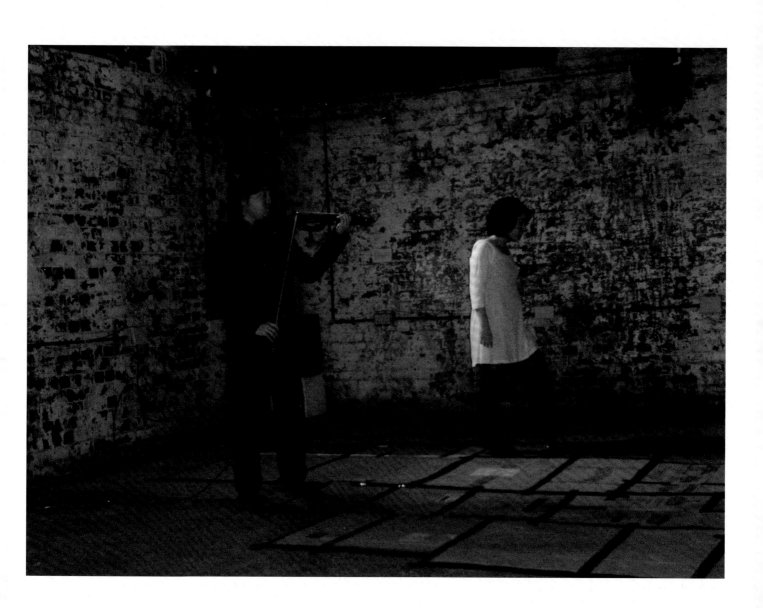

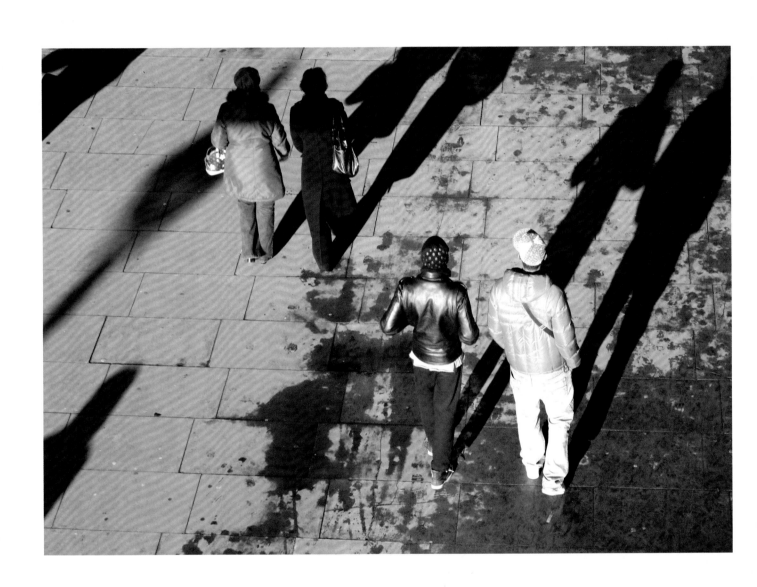

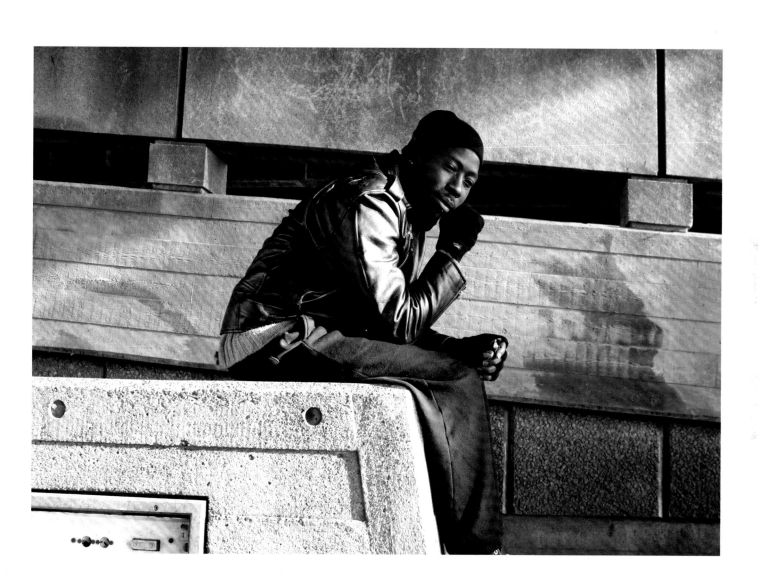

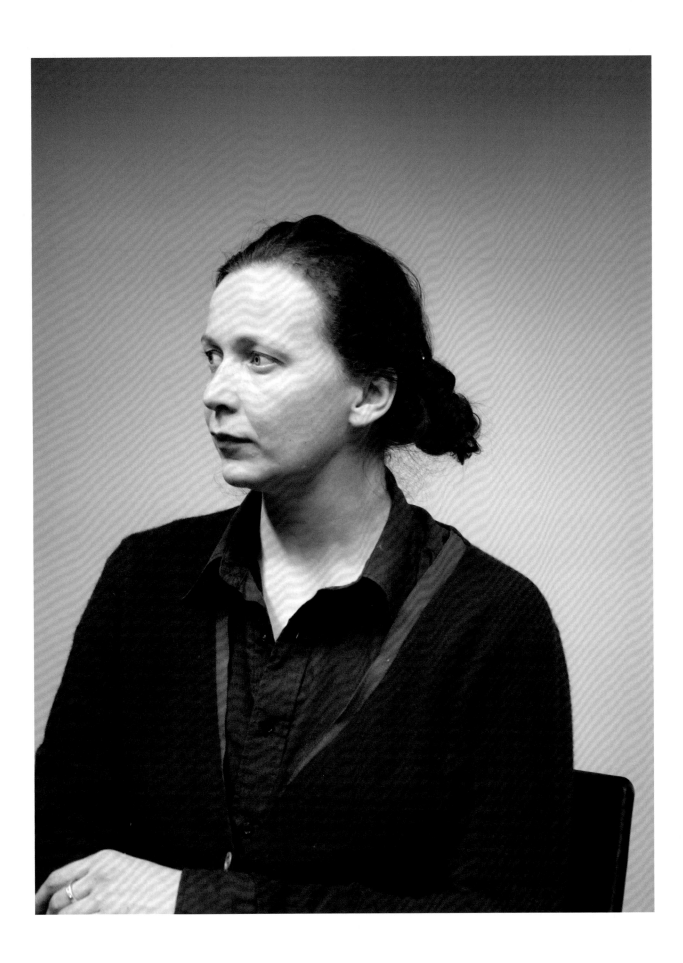

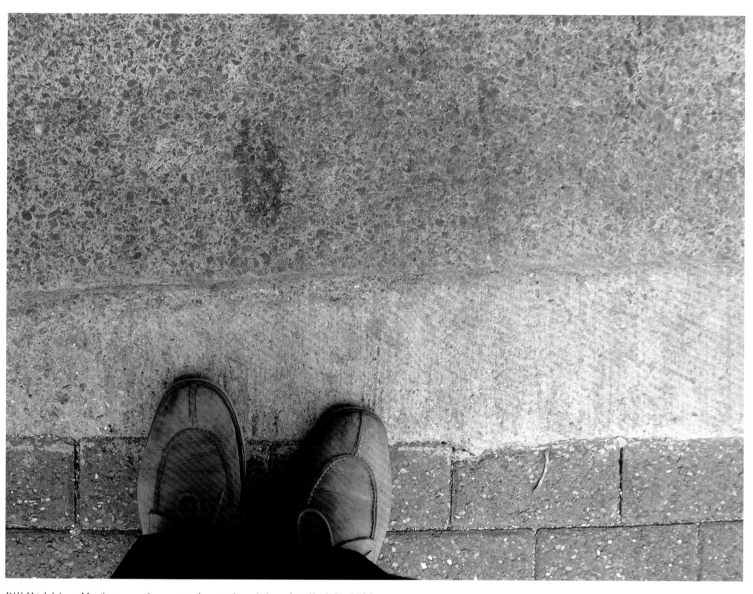

Bill Walthier, *My feet are the central part for giving details*, UK, 2006

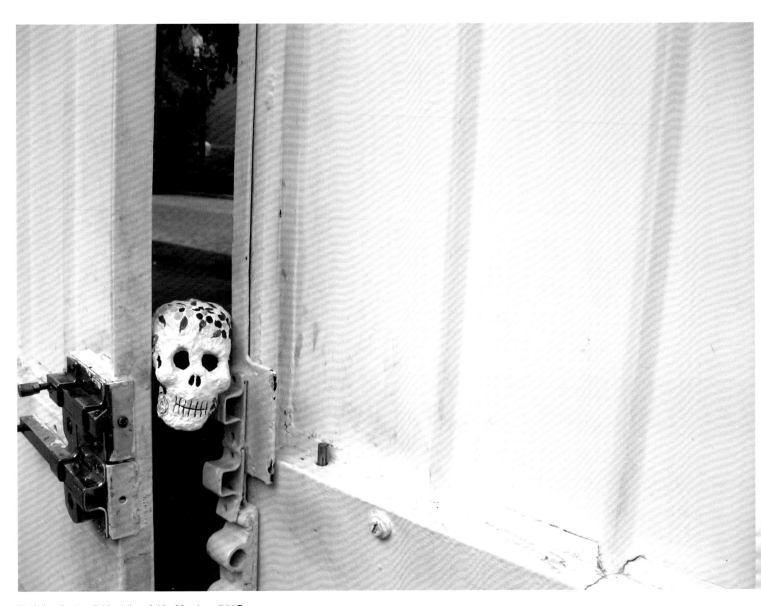

Rubén Ortiz, *Life After Life*, Mexico, 2007
(Rubén Ortiz died in 2014)

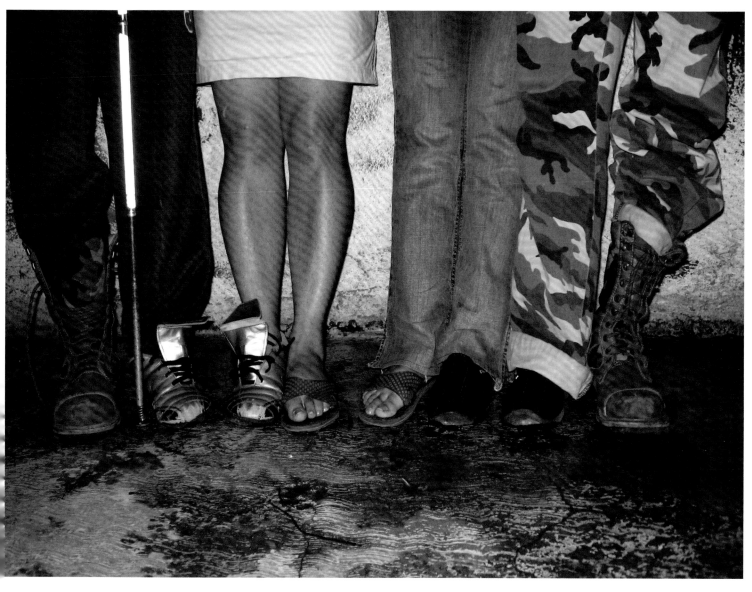

Marco Antonio Martínez, *Empathy*, Mexico, c.2005

"*This picture represents the meaning of empathy, putting yourself in other people's shoes.*"

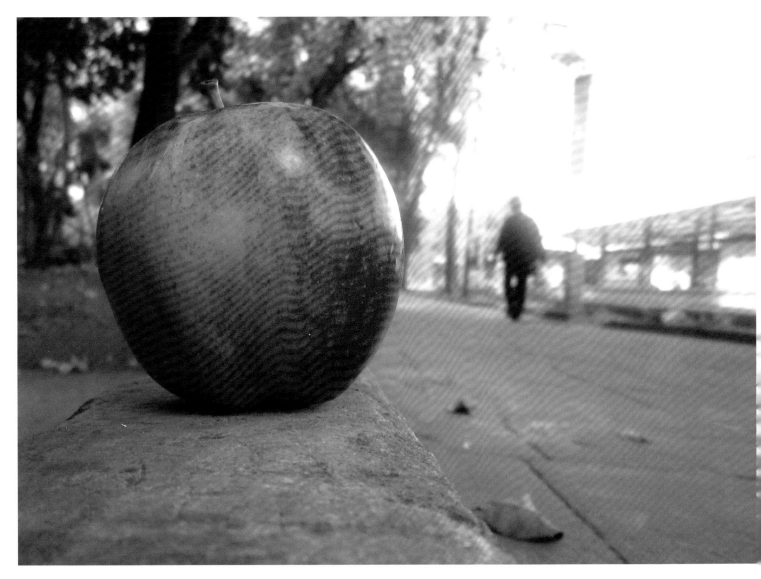

Alberto Loranca, *Untitled*, Mexico, 2012

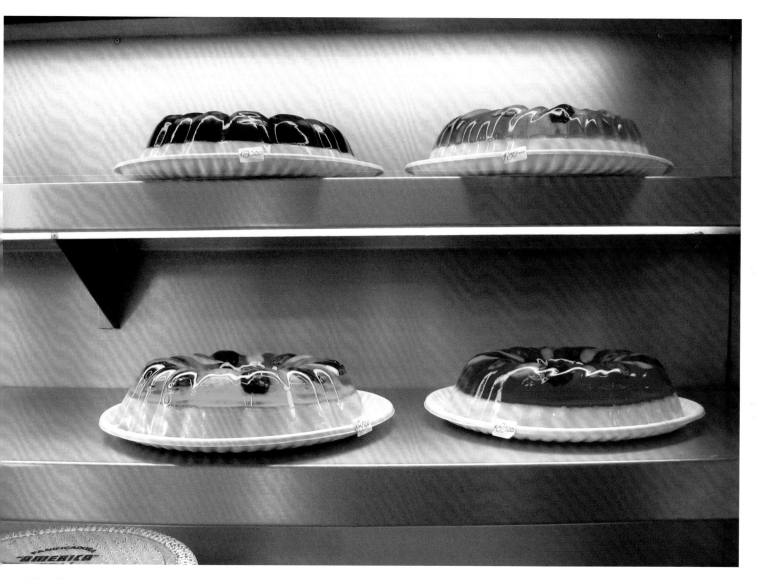

Ana Lilia Carranza, *Untitled*, Mexico, 2007

Miguel Fabián, *Untitled*, Mexico, 2011

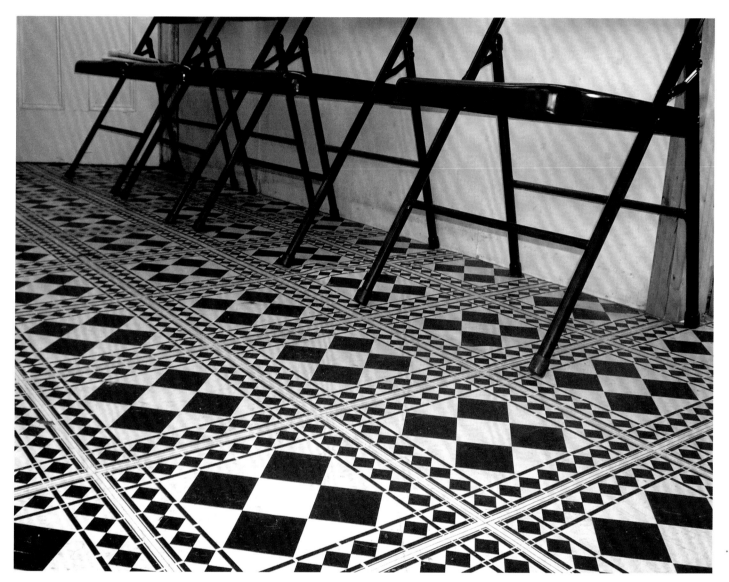

Edward Slyfield, *Untitled*, UK, 2008

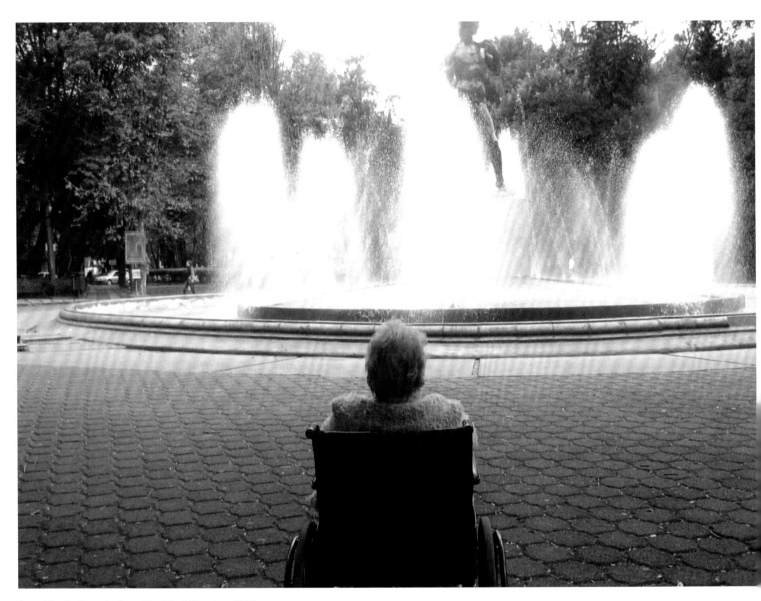

Ana María Fernández, *Untitled*, Mexico, 2012

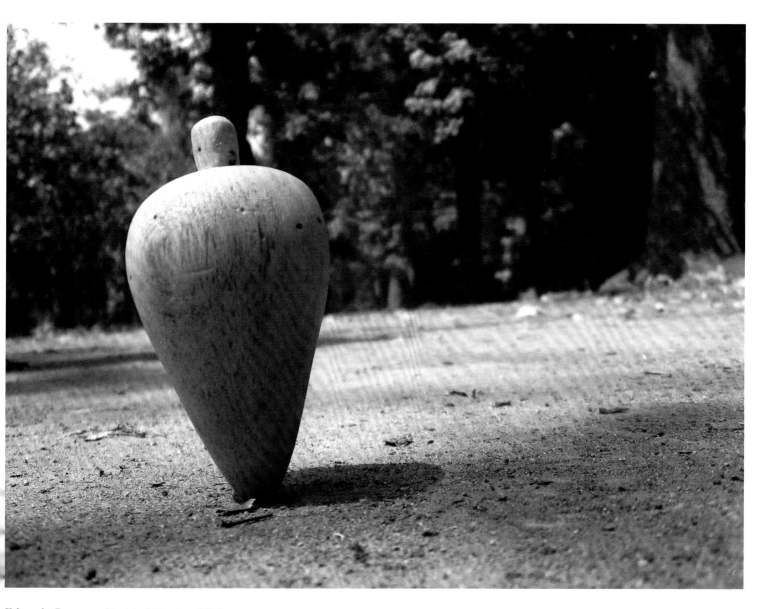

Eduardo Romero, *Untitled*, Mexico, 2010

"This photograph is a reflection of my personal situation, the twists and turns of life moving like the Mexican toy trompo which I carved with my own hands."

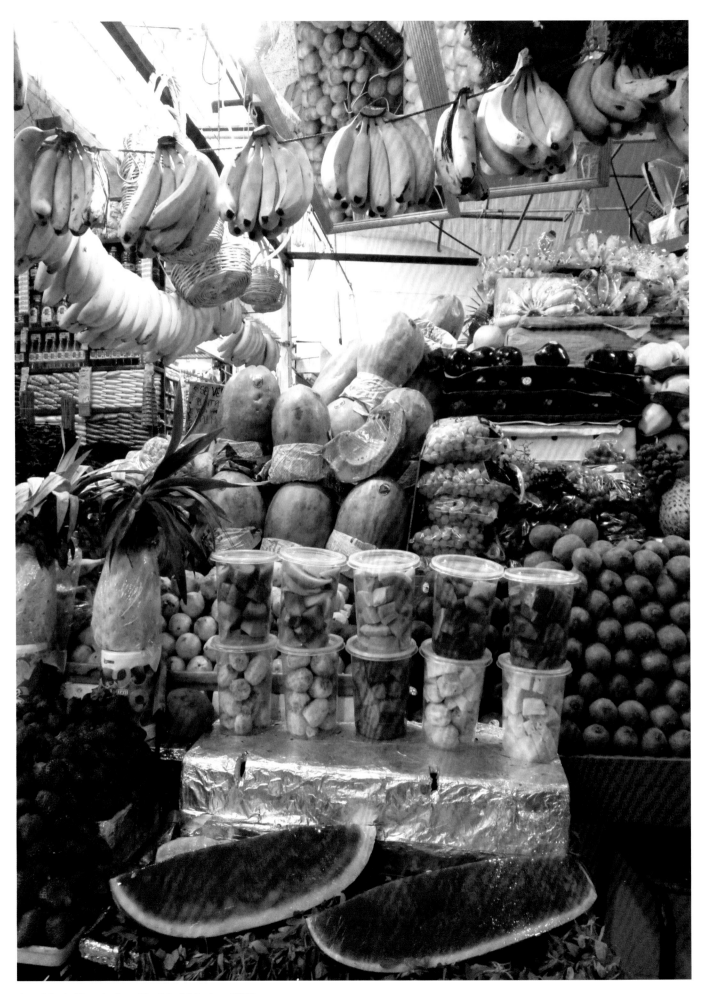

Ana María Fernández, *Untitled*, Mexico, 2012

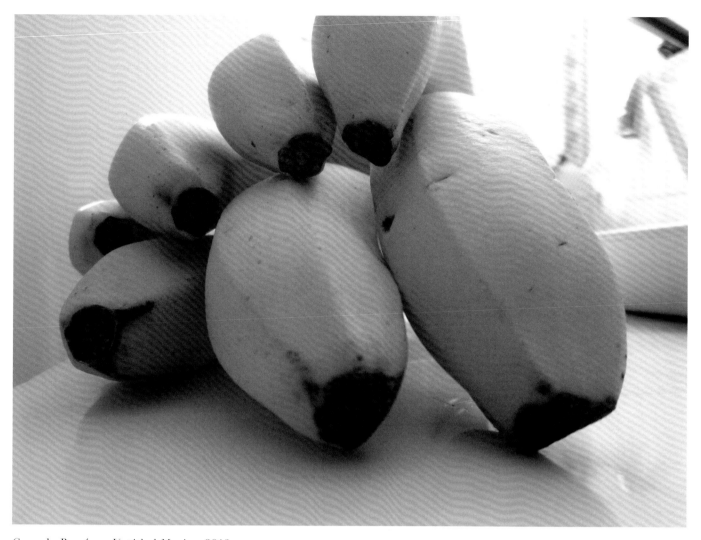

Gerardo Ramírez, *Untitled*, Mexico, 2013

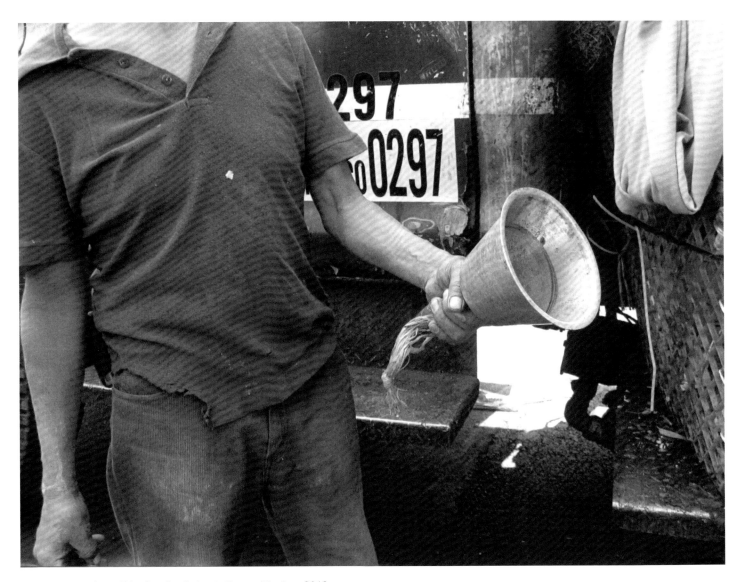

Gerardo Ramírez, *Ringing in Colonia Roma*, Mexico, 2013

GERARDO NIGENDA

In September 2007, Gerardo Nigenda composed a love poem in light and darkness.

A photographic *Song of Songs*.

A subtle and sensuous poem in which the erotics of touch and presence, of anticipation and arousal, of sensual tactility, are discovered in a photography of touching tenderness.

A poem in which the fingertips are the organs of sight, the means to read the beauty of the beloved. Just as the finger reads the braille to hear the words of the song.

A poem in which the sighted might have intimations, an inkling, of the blind photographer's passion through a vision of light and shadow, of unheard words felt along the senses.

The images are accompanied by Nigenda's own titles

Multi-Looks in Corporal Ascension

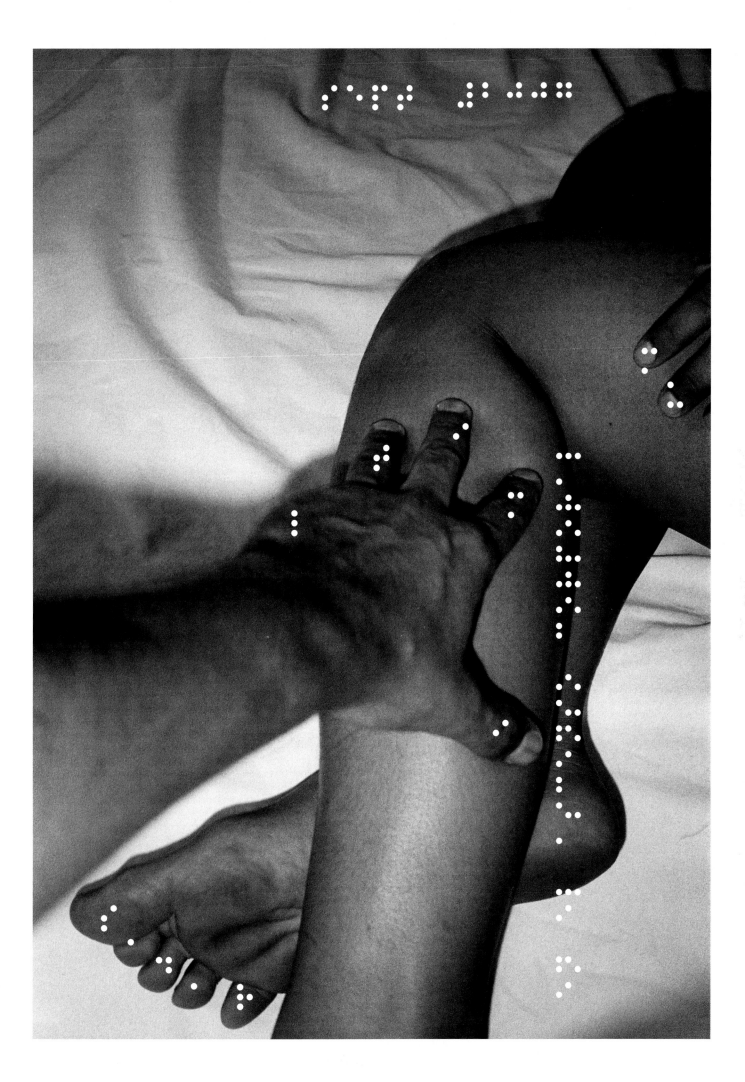

Between the Invisible and the Tangible... Arriving at Emotional Homeostasis

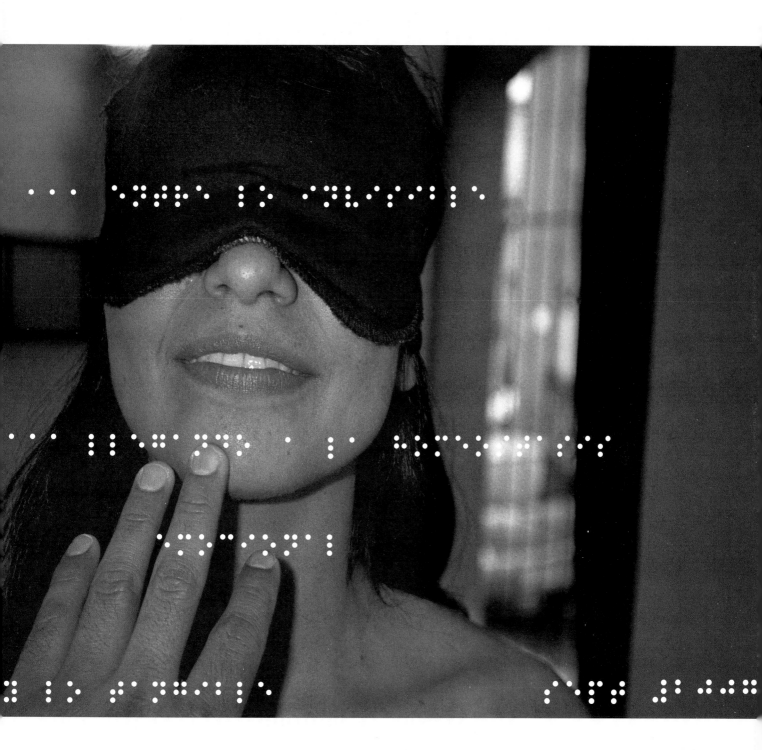

The Fragility of the Initial Reference Induces One to Sensual Evocation

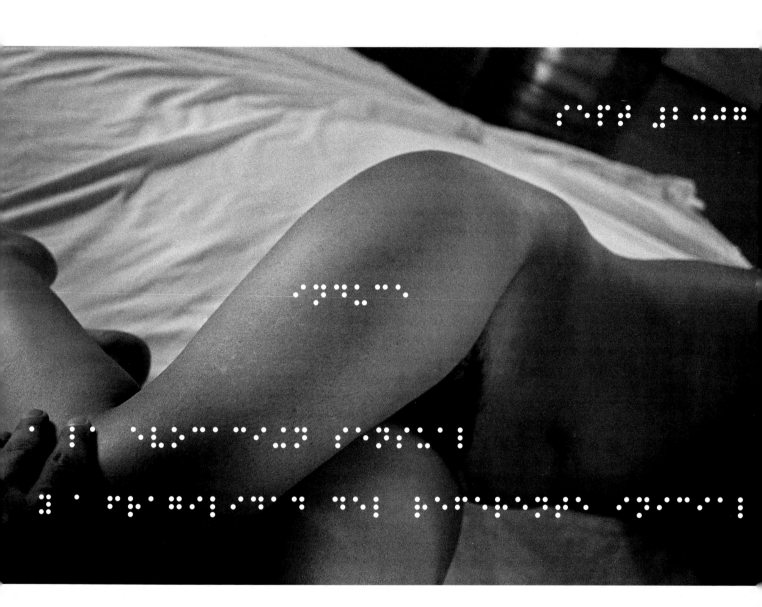

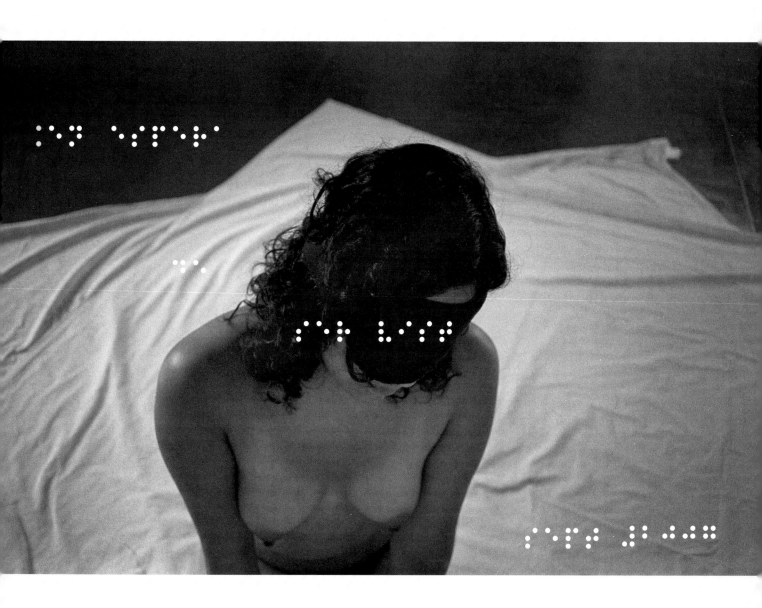

The Subtlety of the Outline Supersedes the Impetuous

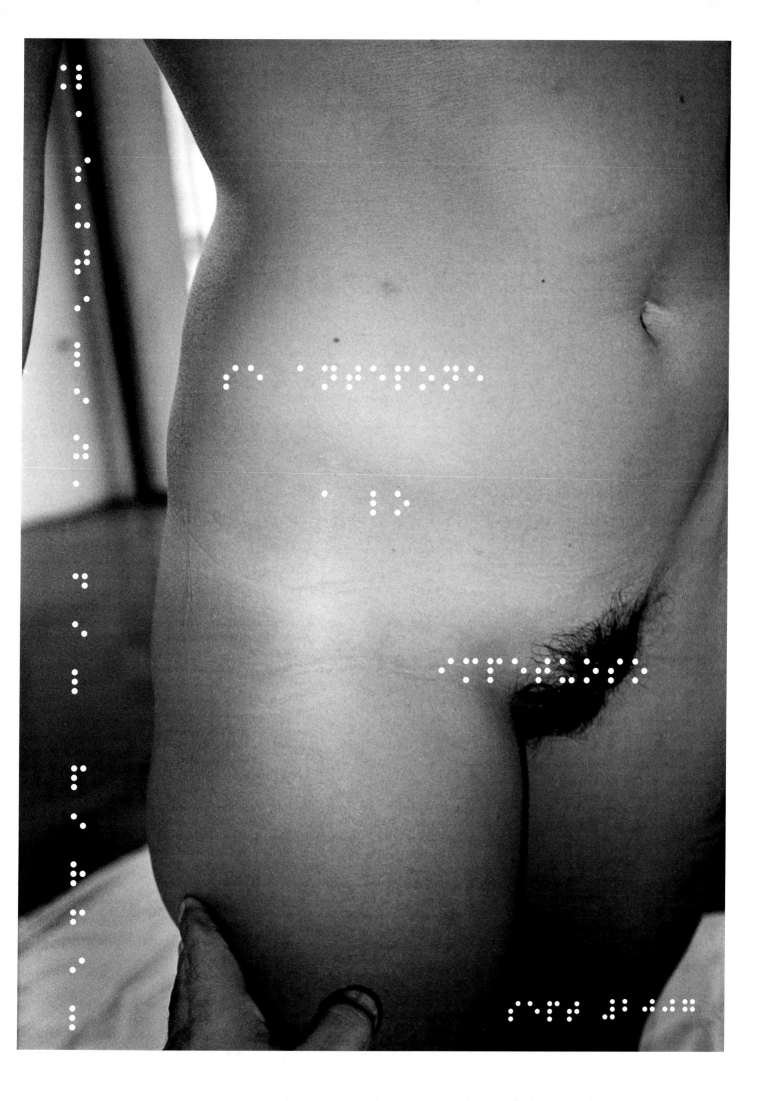

Abraham Sorchini, *Untitled*, Mexico, 2013

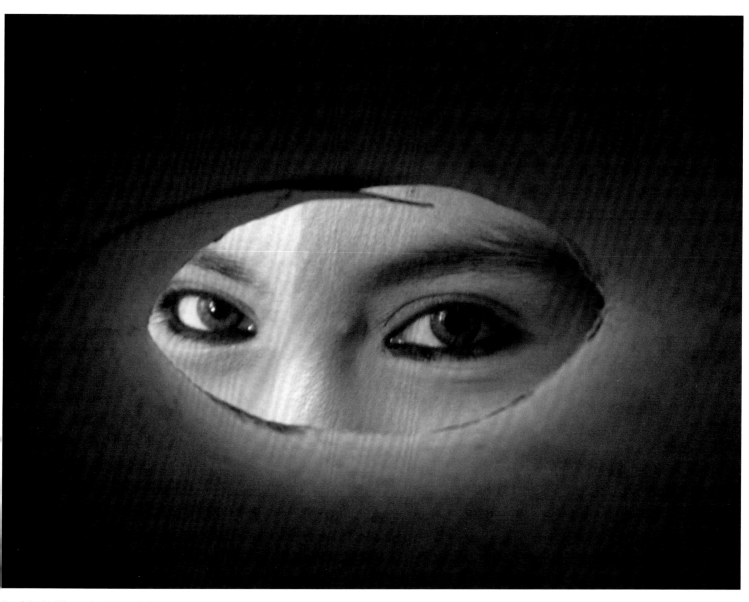

José Luis Mercado, *Untitled*, Mexico, 2013

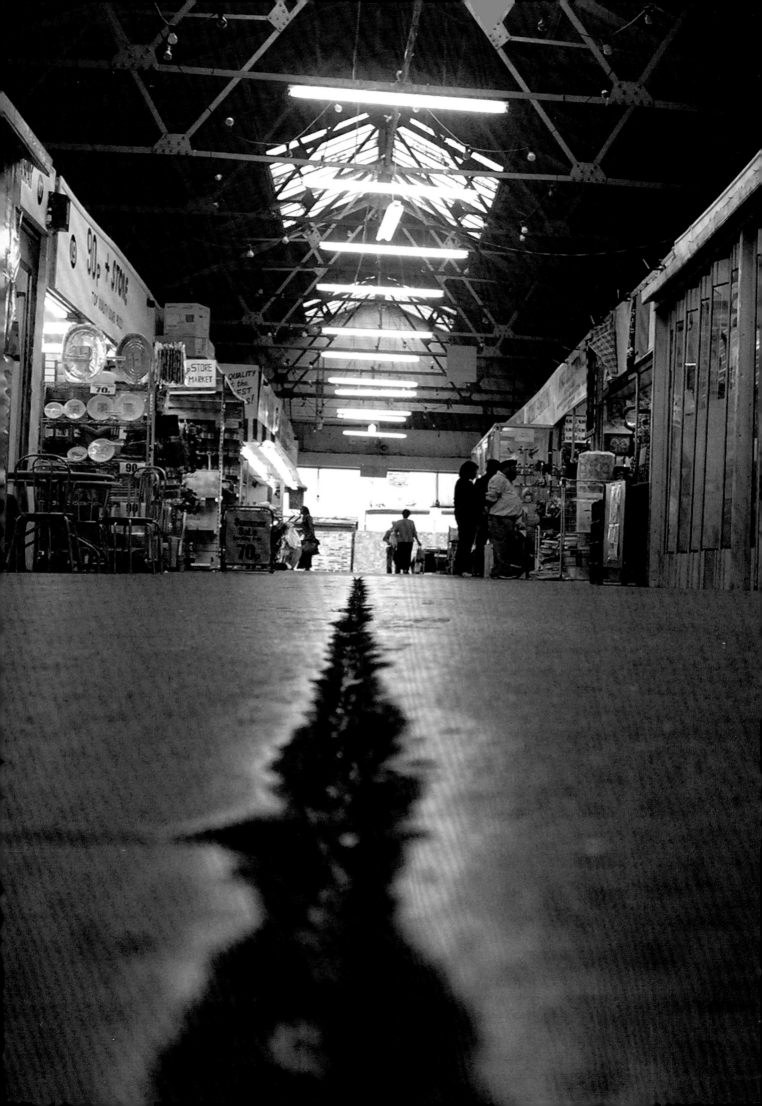

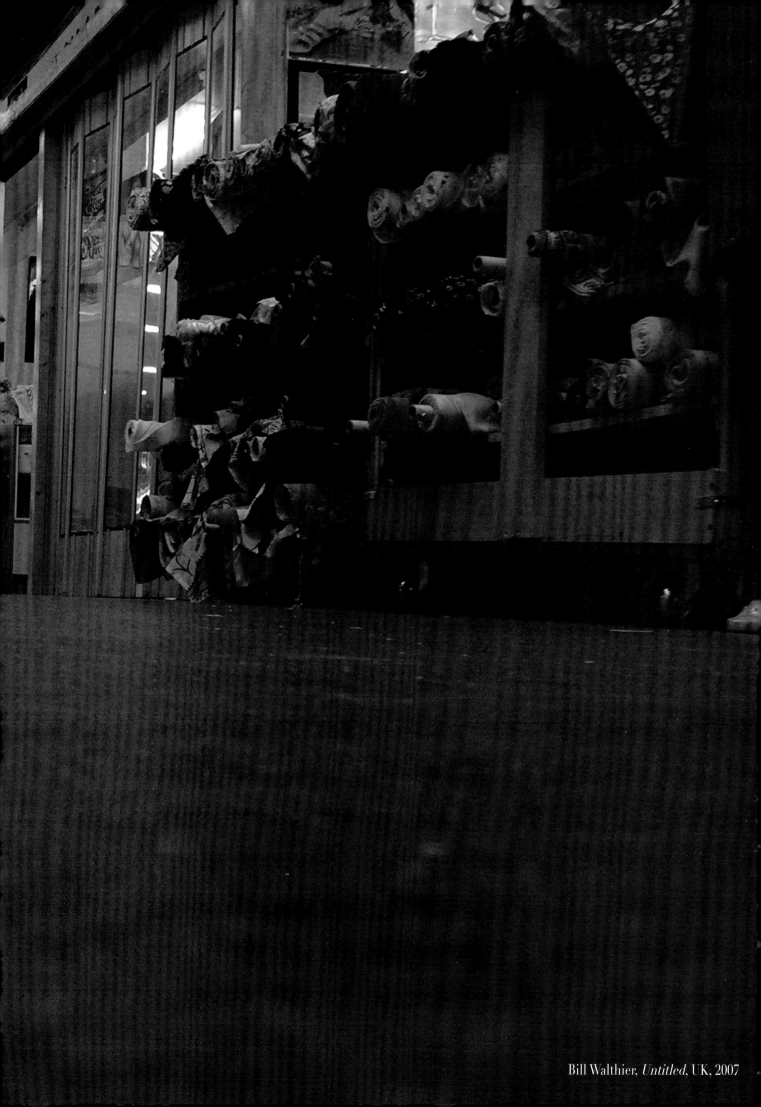

Bill Walthier, *Untitled*, UK, 2007

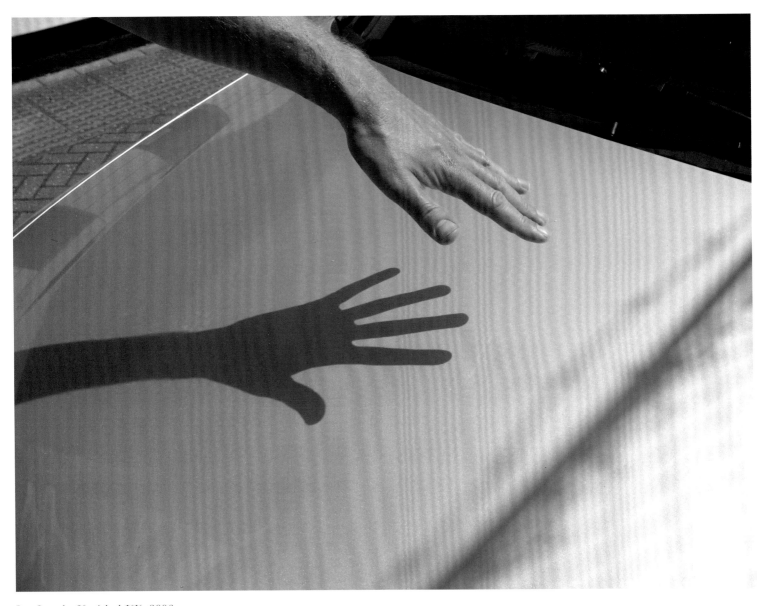

Ian Leask, *Untitled*, UK, 2006

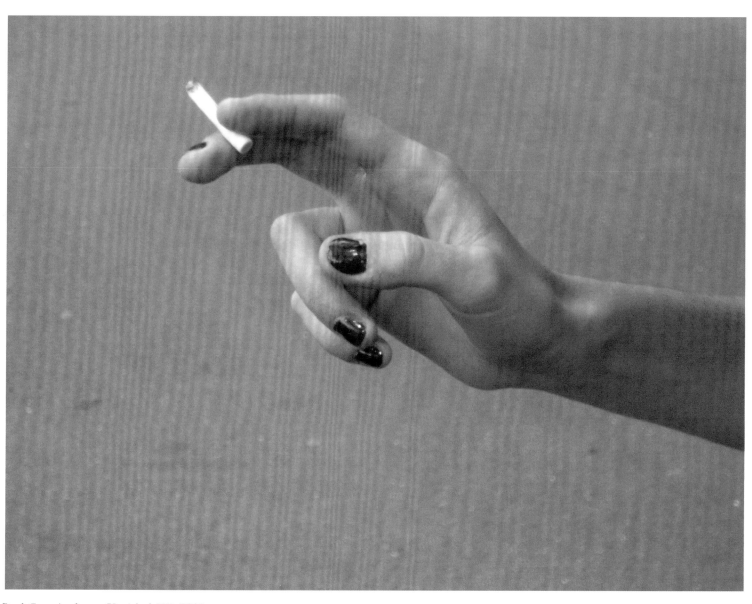

Paul Cunningham, *Untitled*, UK, 2007

OVERLEAF: María Eugenia Cori, *Untitled*, Bolivia, 2008

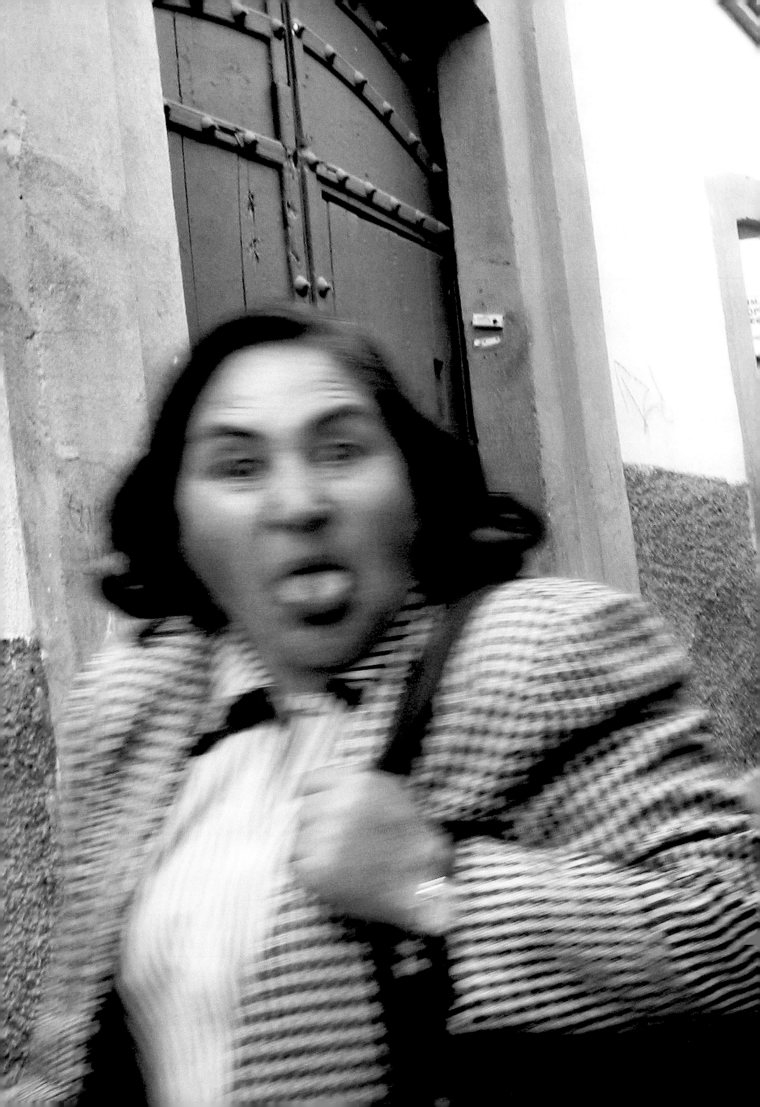

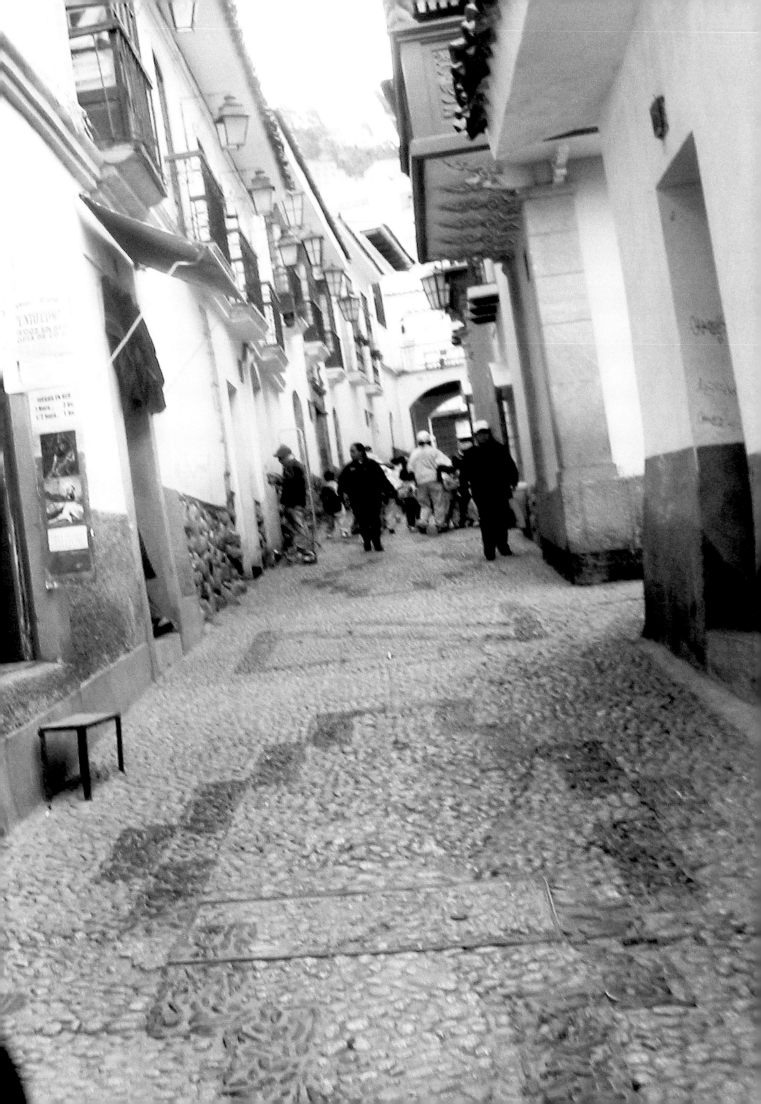

ALBERTO LORANCA

How?

"I can distinguish light and shadow and I pay a great deal of attention to light in order to take pictures; I calculate the amount of light needed using trigonometry. At one point I recalled analytic geometry lessons and thought that if I place the camera in a particular position in relation to the floor and the subject, I can imagine the angles in the shadows and that could help me. I simply deduce how you would see it without too many mathematic operations, and I think I have obtained good results."

Why?

"Photography is something that allows me to give shape to things playing, dancing and laughing in my mind. It is to be able to share such wonders with people. I take pictures because I like it, it pleases me and I take pictures when I marvel at things."

"The Fighter is always with me, sharing my experiences and moments of happiness. The fighter is me, and anyone wishing and making up their minds to start to be different, to raise their awareness and to question their own paradigms, to break down their personal barriers and to achieve change in spite of momentary suffering."

Photographs in this feature are *Untitled*, Mexico, 2011-12

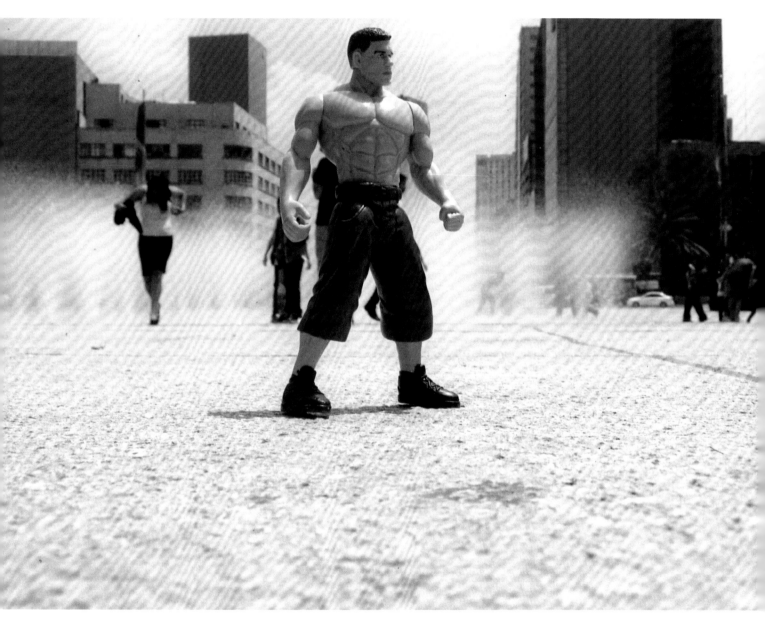

"This picture represents a moment of harmony and greatness..."

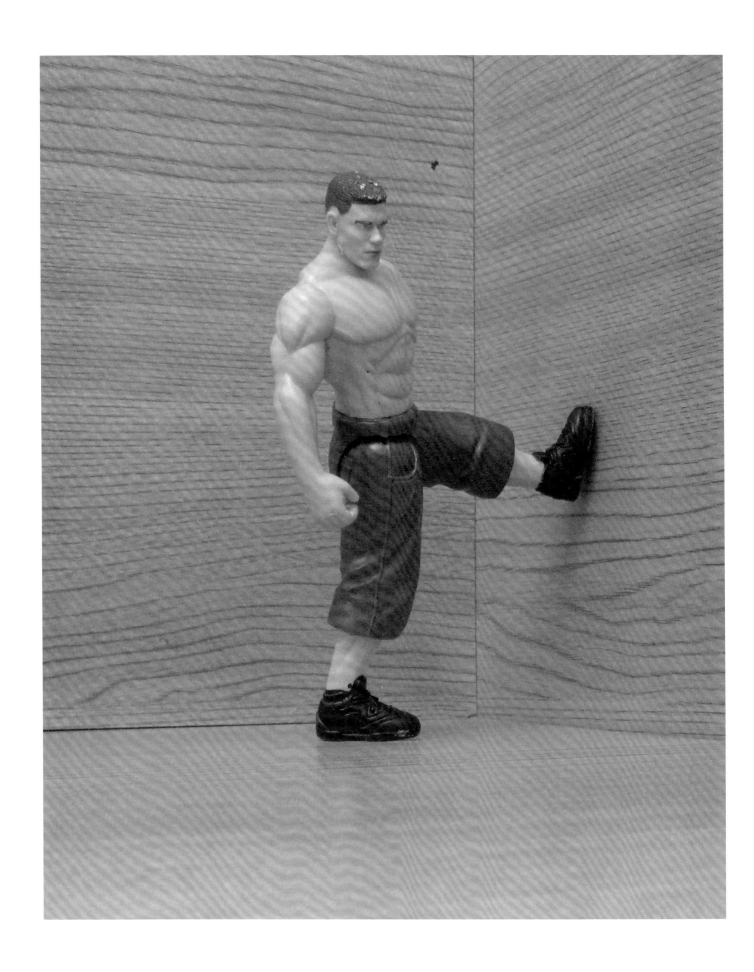

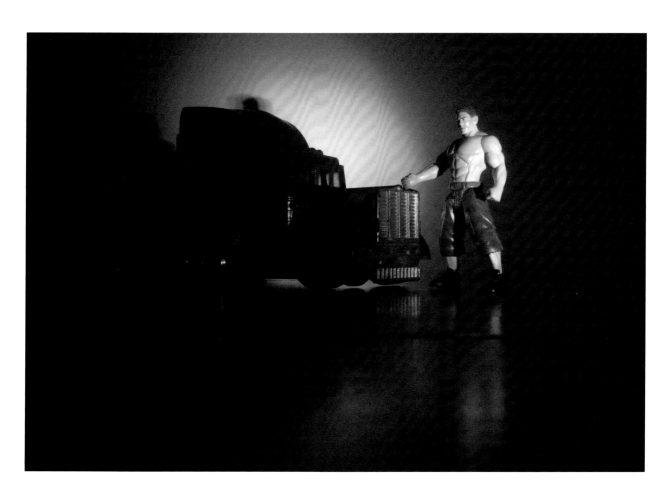

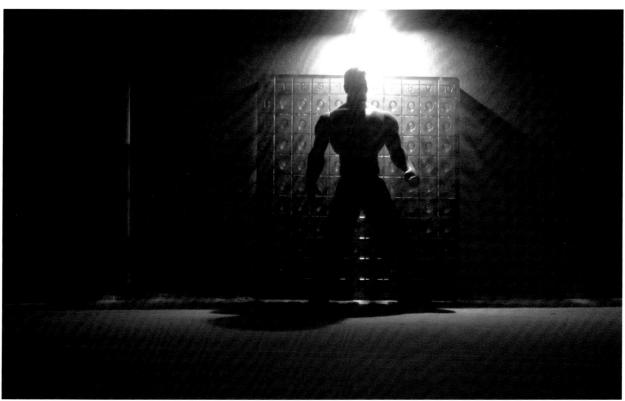

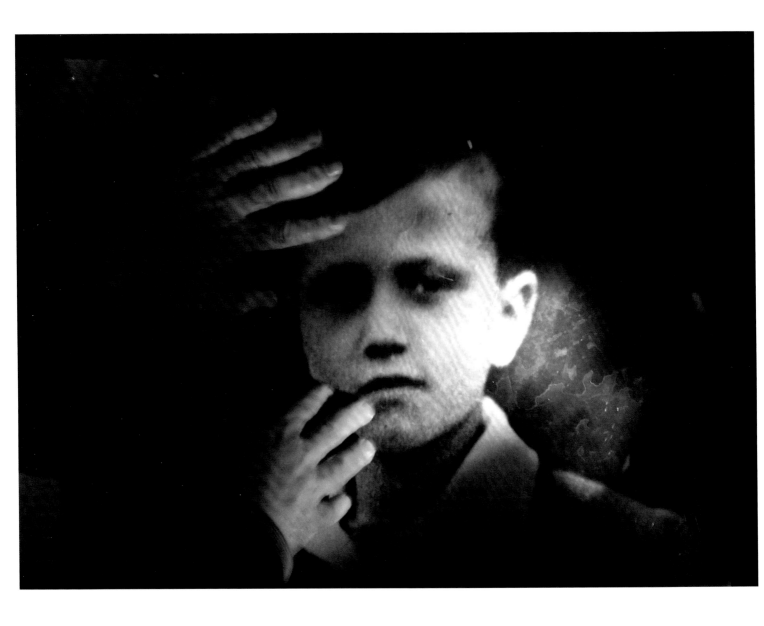

EVGEN BAVČAR

Dreamt, composed in the mind's eye, its objects illuminated in darkness, its dramas contrived by art, light-drawn from desires of seeing: Bavčar's work is itself a timeless European photography of dreams. Epiphanies. Remembrances of things past. Fragments. Oneiric glimpses.

"Photography must belong to the blind, who in their daily existence have learned to become the masters of camera obscura.

Camera obscura has existed for a long time; it is, for example, the concept of the cave in Plato's philosophy and later the invention of the darkroom, which photographers entered blind: in the nineteenth century, the pioneers of photography would veil themselves and join the darkness in order to better control the image appearing on the sensitive plate.

Today, the modern world runs the great danger of lacking in darkness, and one will have to seek the invisible in the quest for new aesthetic solutions. For me, photography does not only represent a medium of artistic expression; it is also a manner of reclaiming one's right to the image, and the refusal to be another's passive model.

All the images that I create exist beforehand in my mind and are perceived by my third eye, that of the soul.

Being a philosopher, I am passionate about art history. I sometimes meditate upon the following phrase: 'The more the visible world grows, the more the invisible world shrinks', And so the words of Kazantzakis come back to me: 'Such a shame for our eyes of clay, which cannot attain the invisible.'

But this world is here; it is, so to speak, within arm's reach."

All Evgen Bavčar's photographs are untitled and undated.

Translated by Sydney Diack

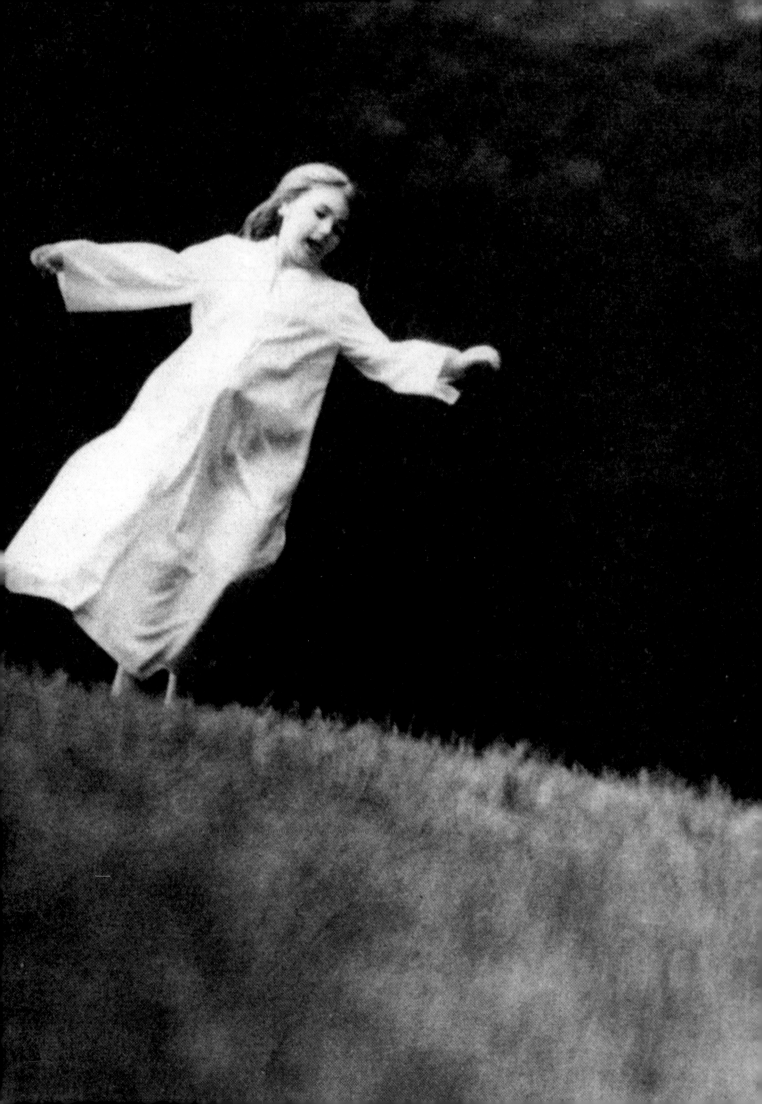

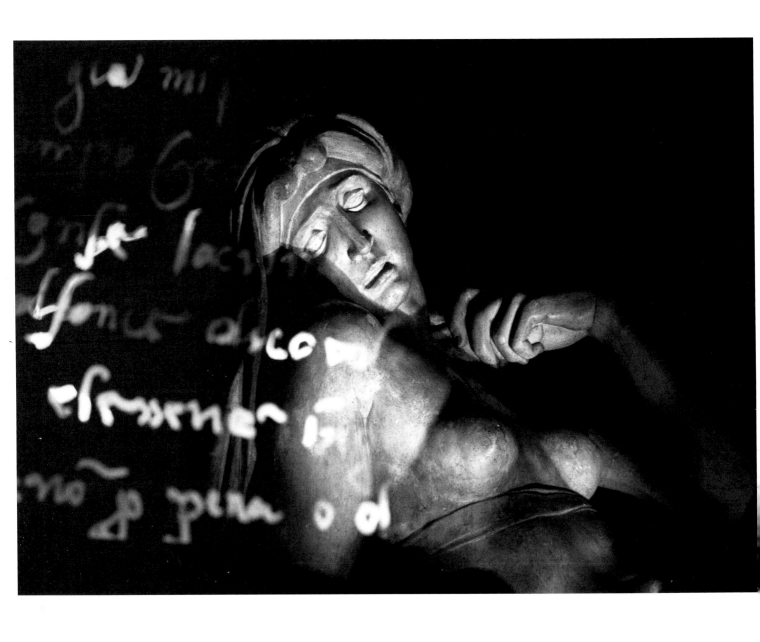

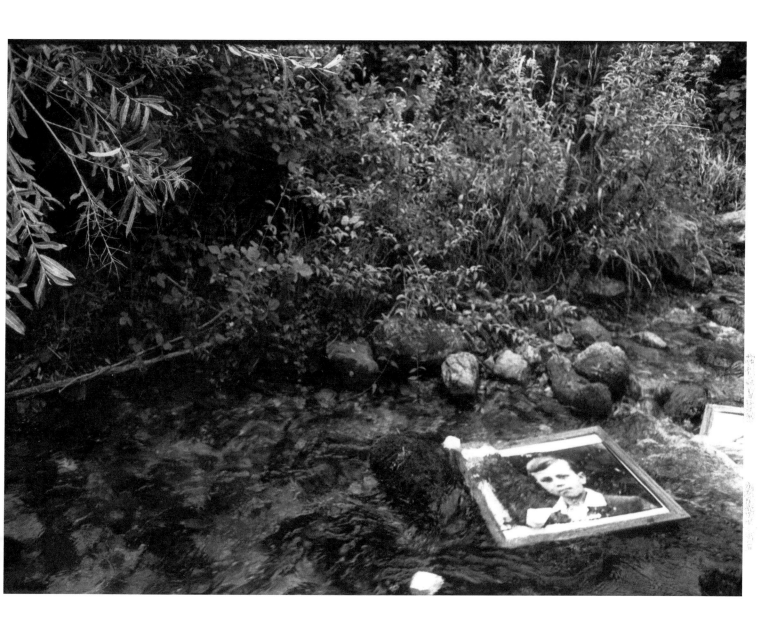

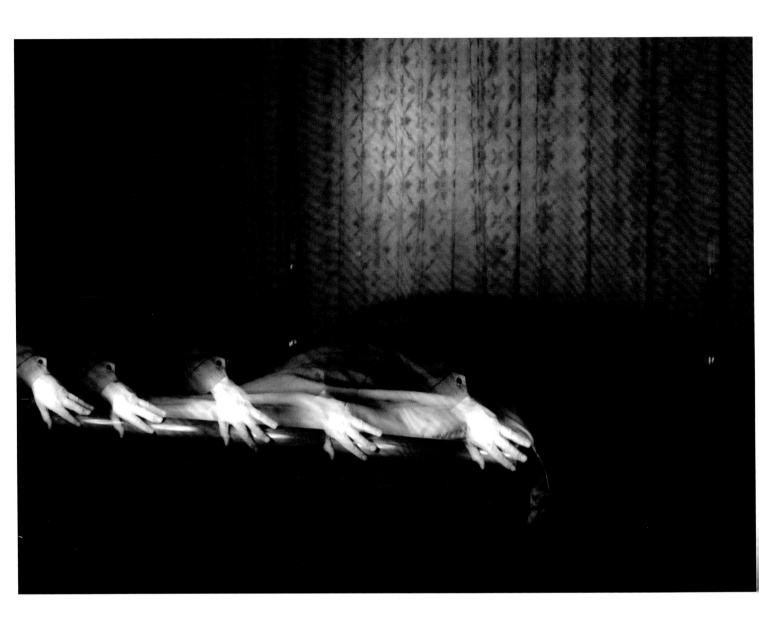

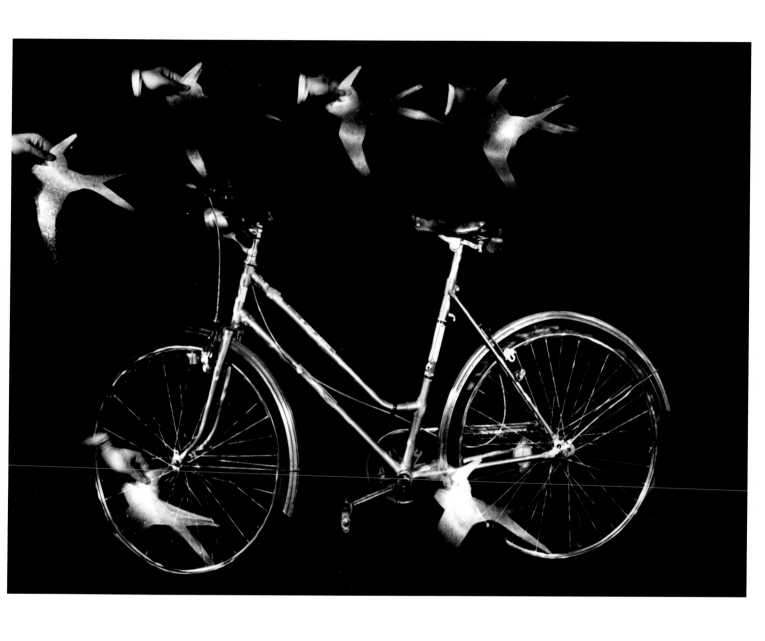

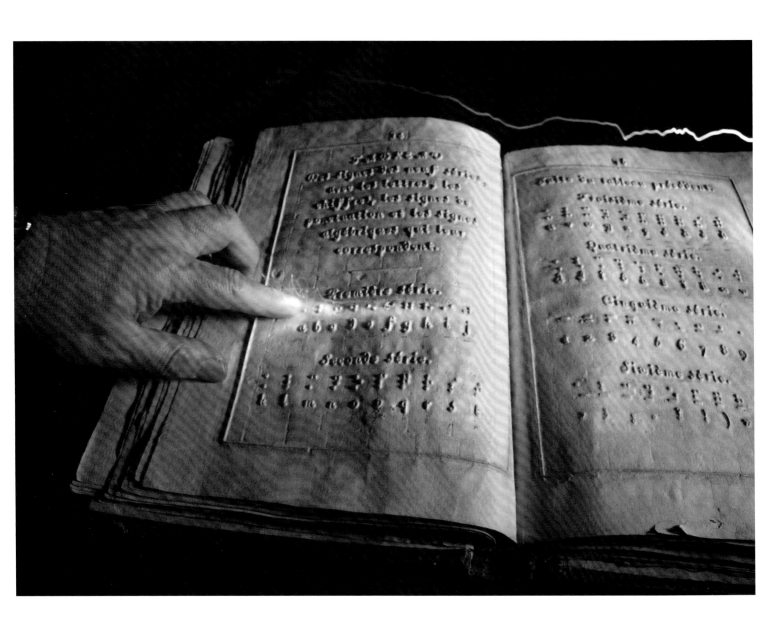

JASHIVI OSUNA AGUILAR

"Photography is like a partner to me: it shows me the way each day, creating responses from others, and helps me rediscover the light and the shadow within me."

Marfan Heart, Jashivi Osuna Aguilar's 2012 photographic series, is concerned with two events that have shaped her life. At six she was diagnosed with the rare Marfan Syndrome, which would drastically harm her eyes and heart: *"From that day onwards, I came to perceive myself as 'different'; I felt the weight of such a condition, and bore a thousand other frustrations on my shoulders."*

The second event occurred at the time when she was gradually losing her sight; she was surviving heart surgery for a second time, not knowing if she would recover. Physically exhausted and mentally confused, a quarrel with her husband would lead to their separation: *"… I remember the last words I said, through a difficult and painful breathing: ' I want you to go; but I want you to go away from my life for good.' I couldn't say which of those two situations hurt most. From that moment on, my recovery was firm and determined…"*

Today Jashivi is blind and her third heart operation is getting closer. *"It has taken me a long time to get to where I am. Because of my past, and because my spirit has expanded, the weight on my shoulders feels lighter. I walk with difficulty, but my heart, strong, noble and intense, always finds the way for me. This is why I have called this photographic series* Marfan Heart.*"*

Jashivi Osuna Aguilar died in June 2015.

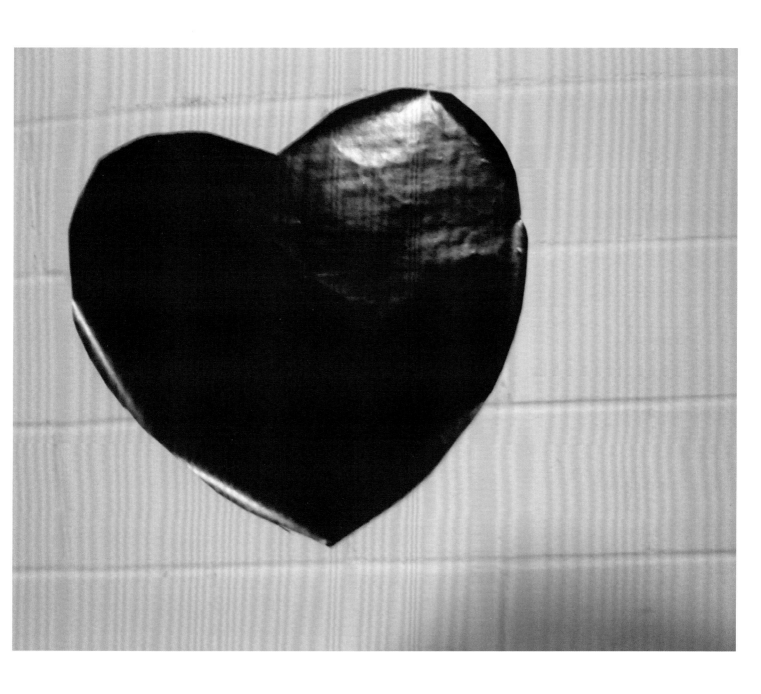

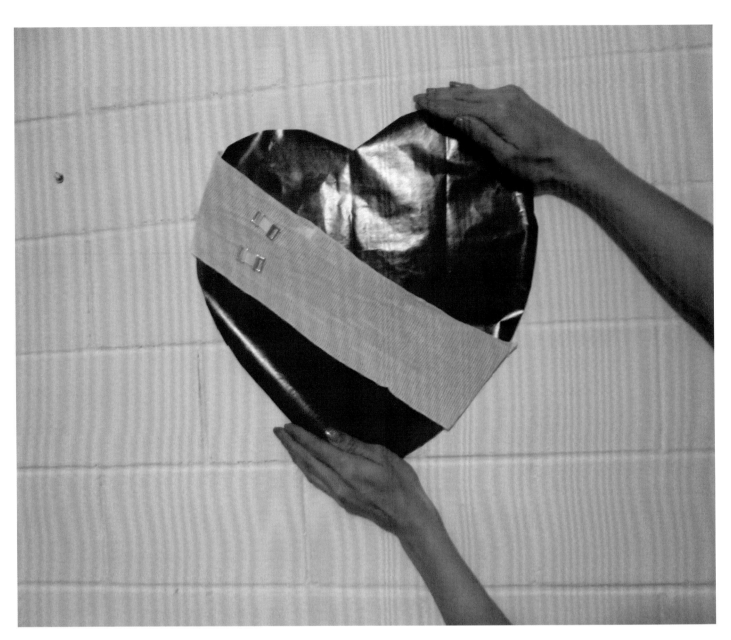

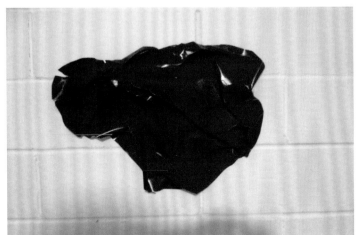

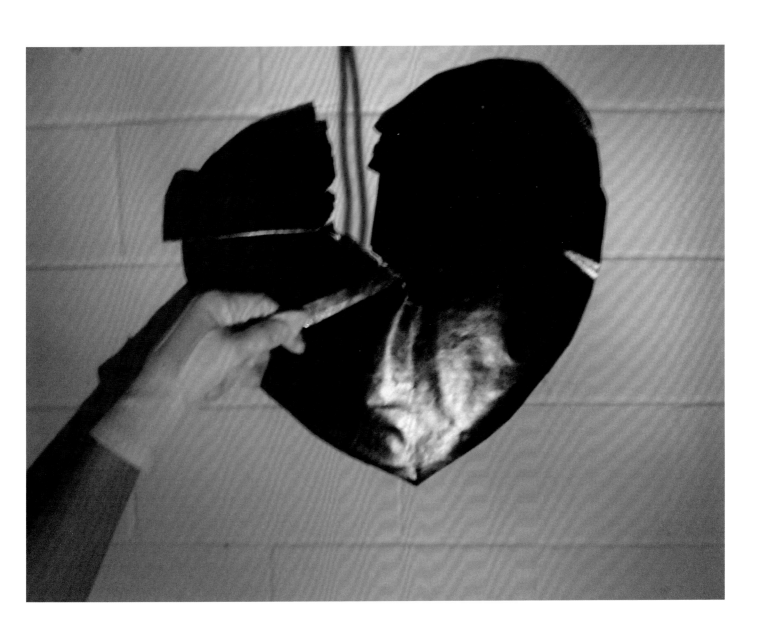

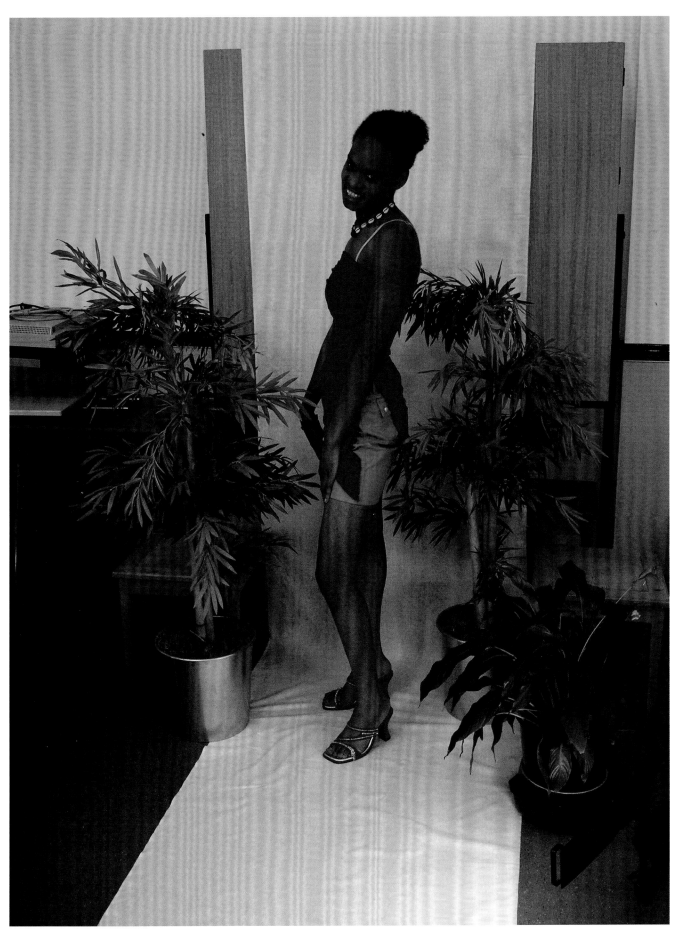

Ramona Quacy Williams, *Fashion show*, UK, 2007

Gary Waite, *Untitled*, UK, 2010

Gary Waite, *Untitled*, UK, 2010

ANA MARÍA FERNÁNDEZ

The photography of Ana María Fernández, so full of colour and light and space, is, like that of many blind photographers, especially replete with evocations of those senses that the blind share with the sighted. It is as if it is her intention to make the seer more intensely alert to that which is not seen – however spectacular the prospect may be to the eyes – but smelt, tasted, heard, touched: the smell of spring grass, the freshness of spring air that salts and savours the sweet joy of spring lovers; the intense scent of flowers in an indoor peacock garden; the silence of a street band that poses for her in the quietude of the siesta; the fulgent notes of a solitary trumpet in a silent echoing street; the smell and shape of fruit, stacked in the open market, spread for lunch in the warm enclosure of a sunlit room.

Photographs in this feature are *Untitled*, Mexico, 2012-14

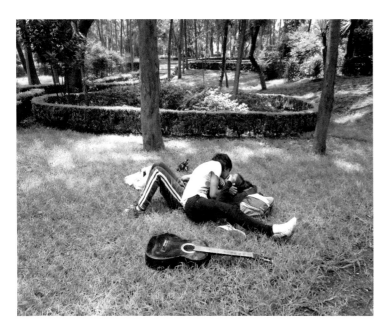 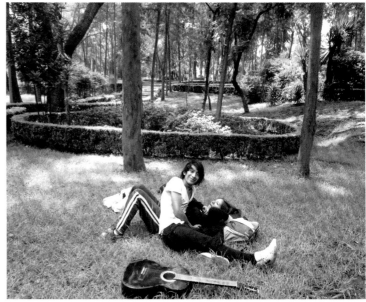

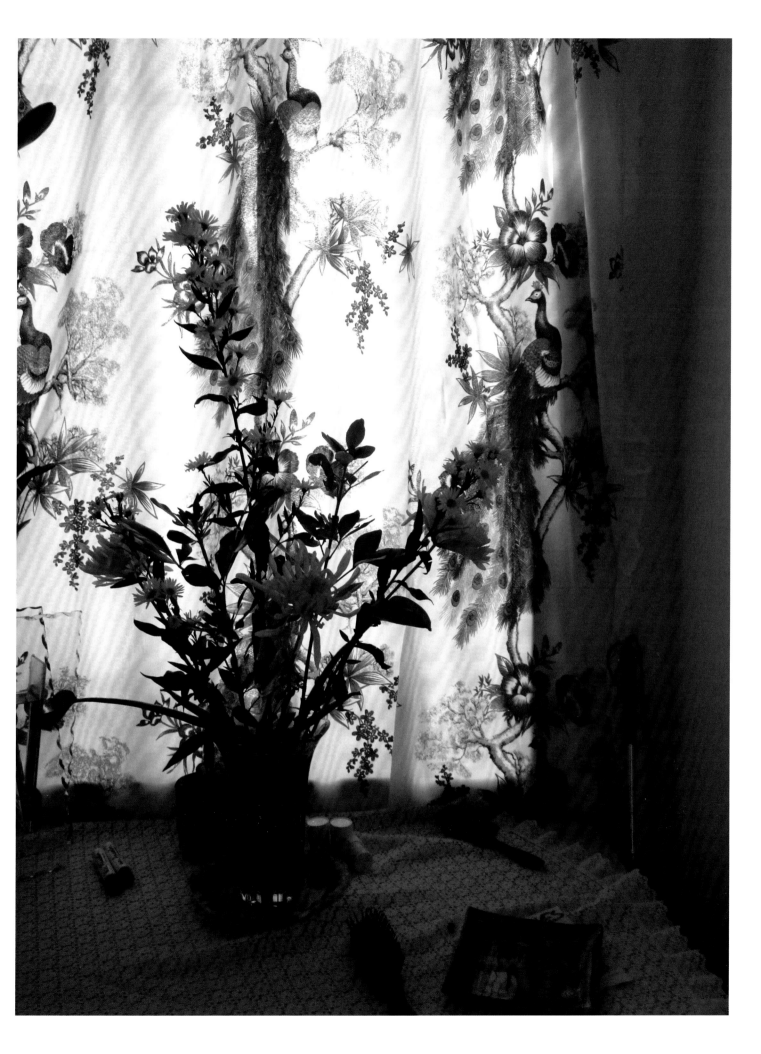

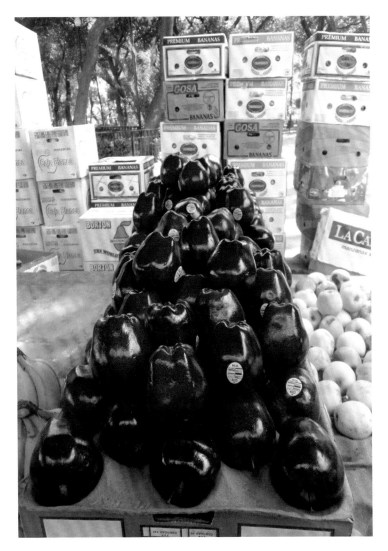

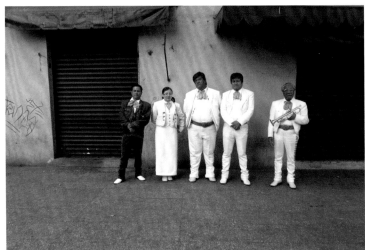

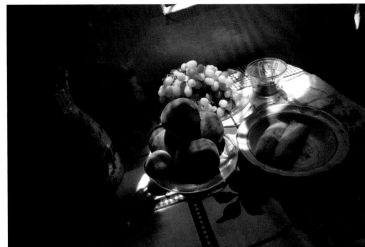

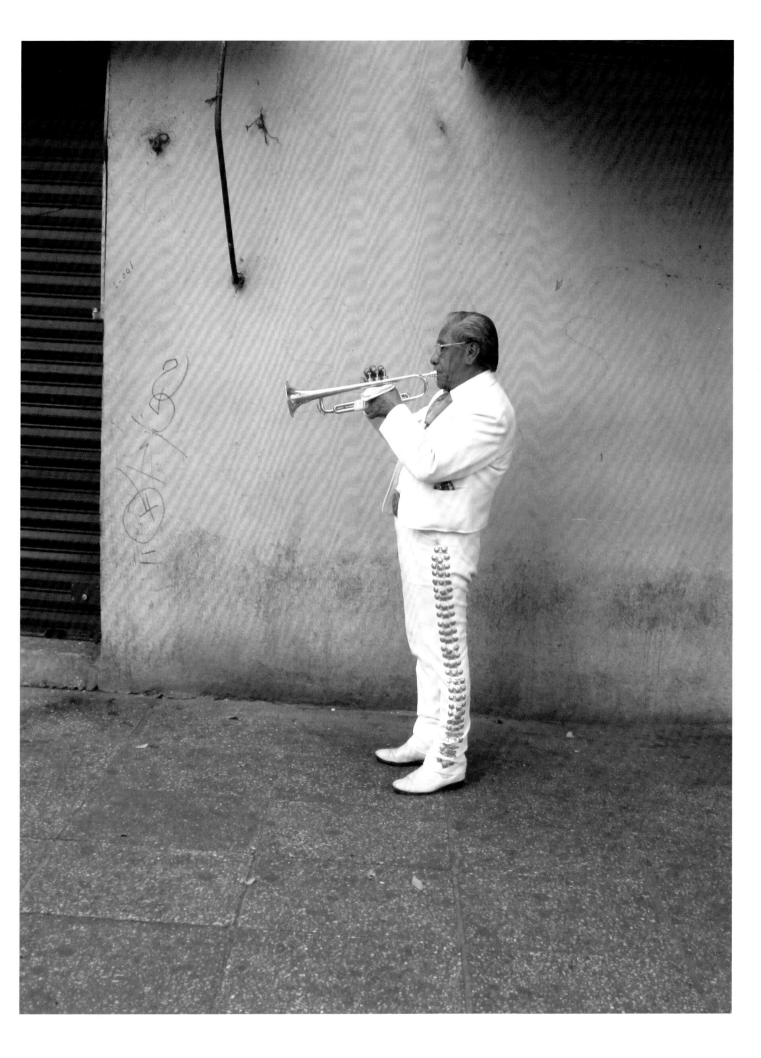

FROM INDIA

There is a distinctively poetic cast to these photographs from India. A poetry without words; a photography without programme. A silent wordless typewriter; the setting sun caught momentarily in the silhouetted hand; the blind girl who hears the unseen camera's click; the positive hands that reach for their negative images; the human voices of shadows against a shining afternoon sea: it is a poetry of oppositions and nuances, of shadows and light, of silence in sound. It is a poetry of the imagined moment – present and real, immediate and timeless – transfigured.

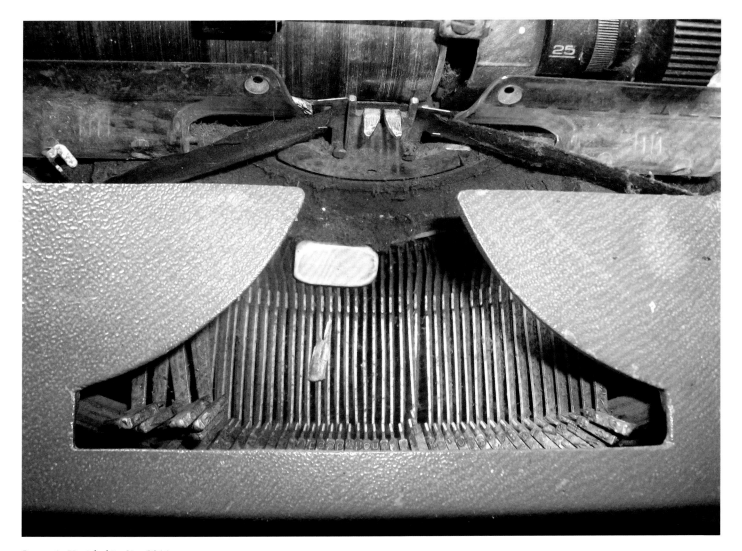

Pragati, *Untitled,* India, 2011

Pranav Lal, *Untitled*, India, 2011 (shot with a pinhole camera)

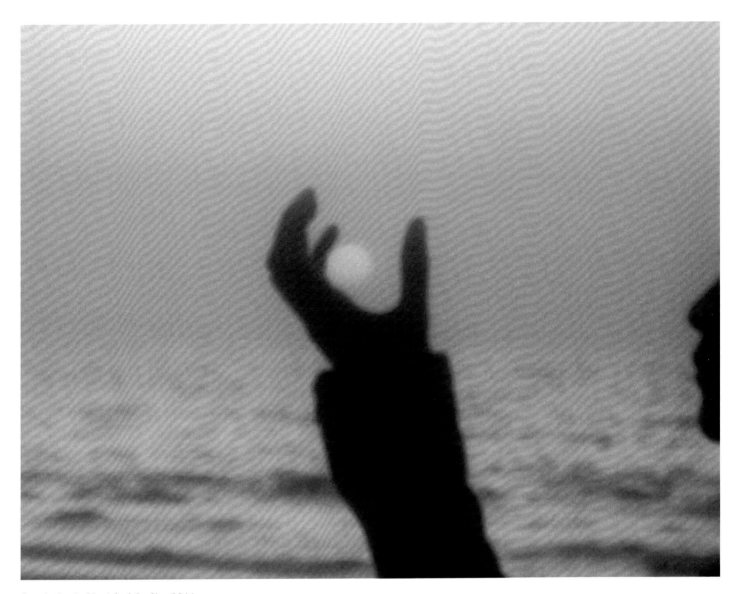

Satvir Jogi, *Untitled*, India, 2011

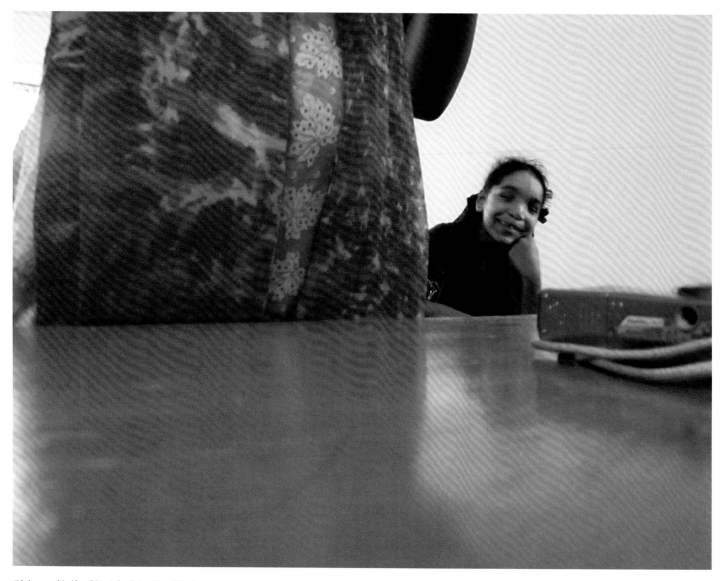

Shivam Naik, *Untitled*, India, 2011

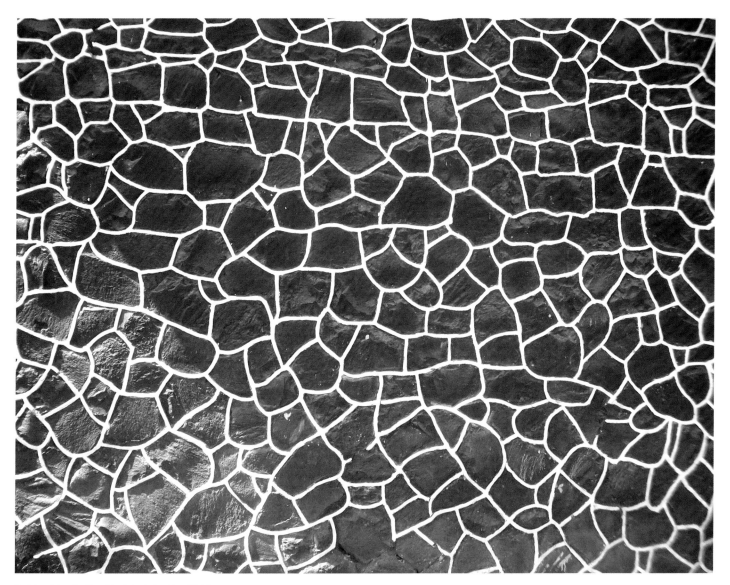

Fahim Tamboli, *Untitled*, India, 2012

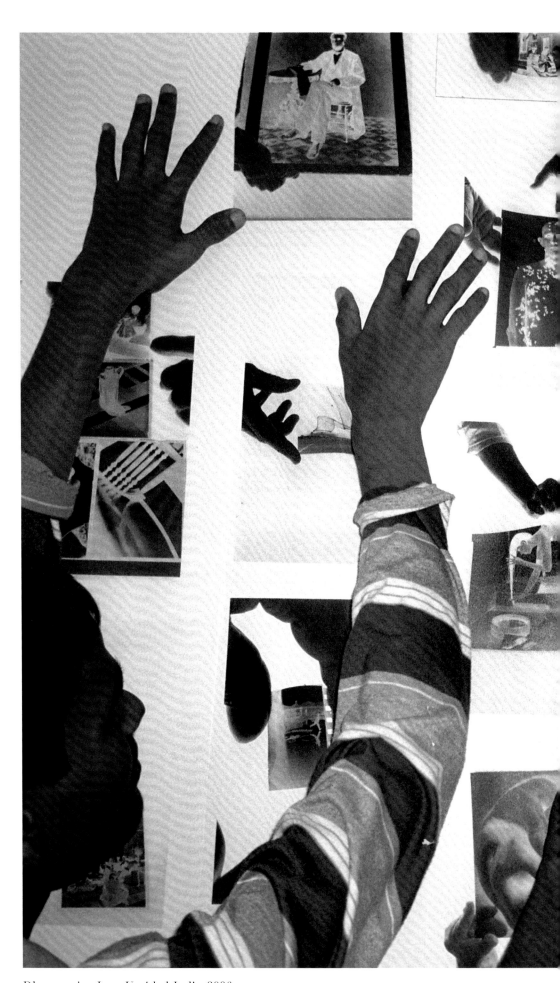

Dharmarajan Iyer, *Untitled*, India, 2006

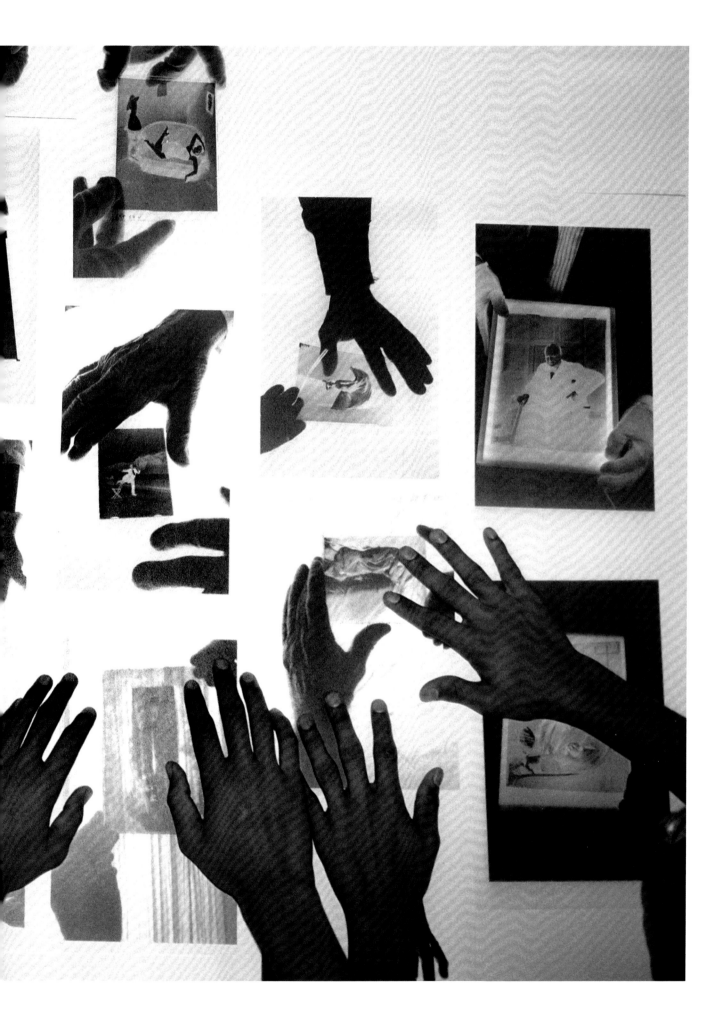

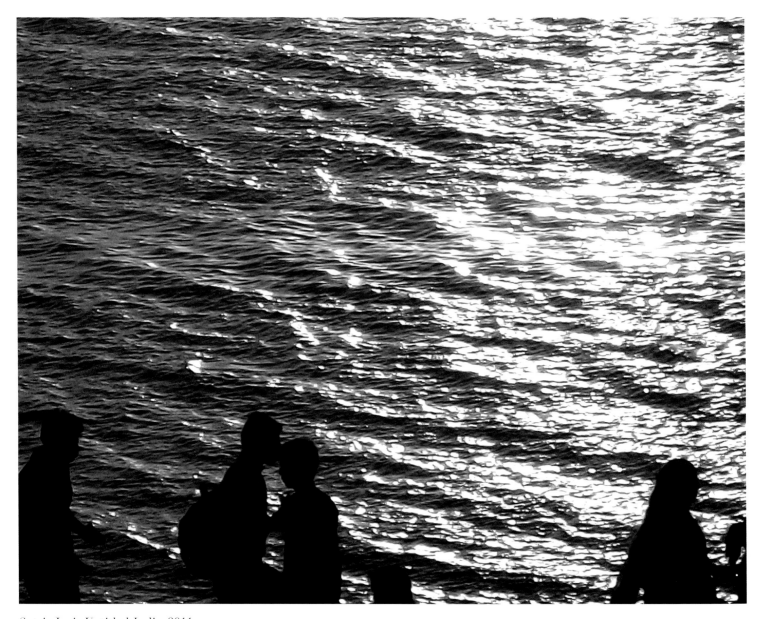

Satvir Jogi, *Untitled*, India, 2011

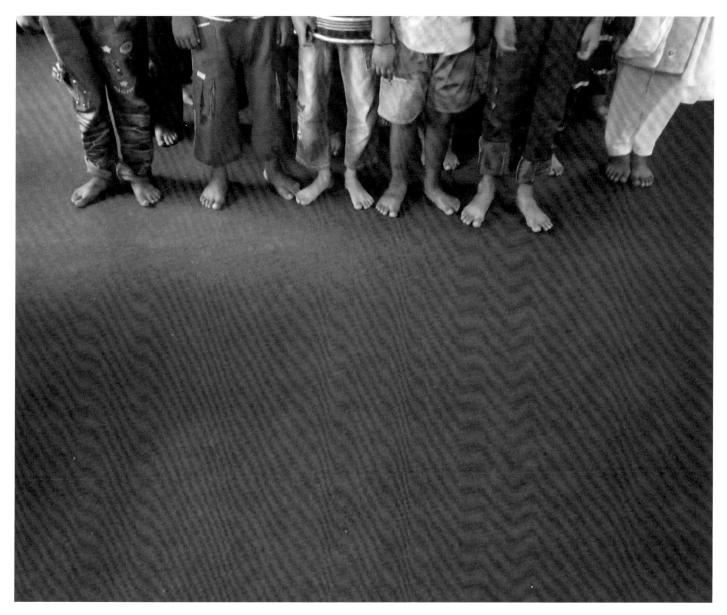

Satvir Jogi, *Untitled*, India, 2011

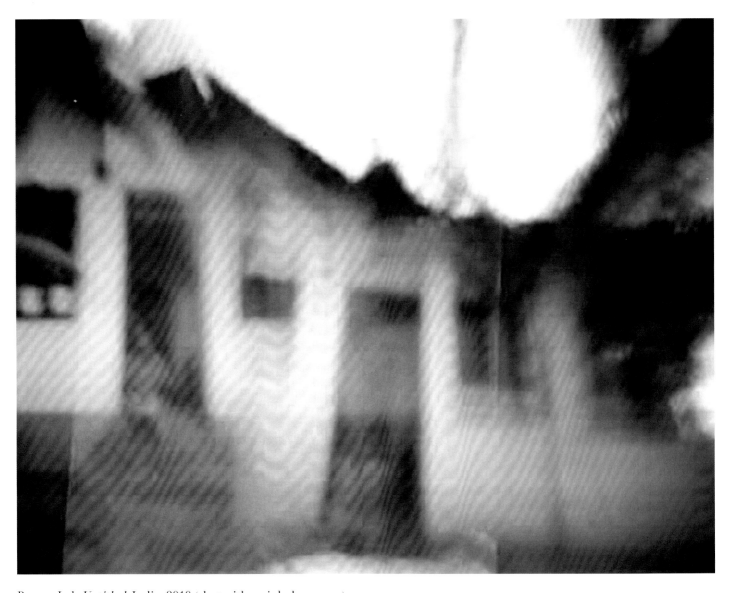

Pranav Lal, *Untitled*, India, 2010 (shot with a pinhole camera)

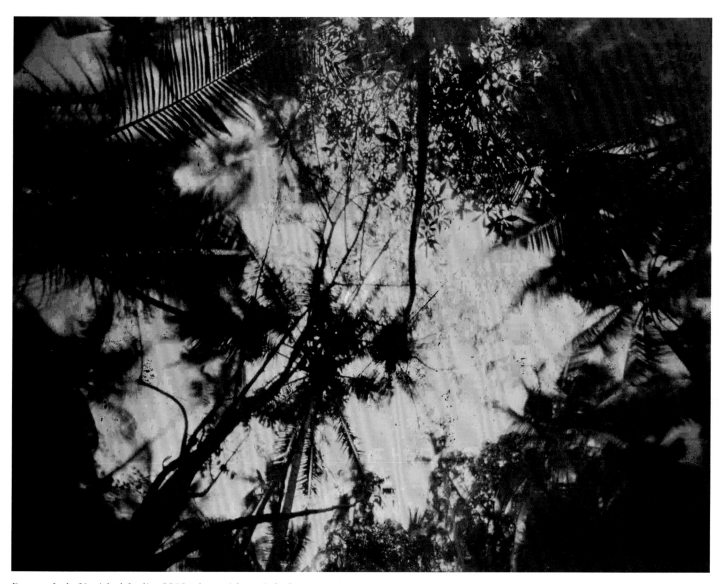

Pranav Lal, *Untitled*, India, 2010 (shot with a pinhole camera)

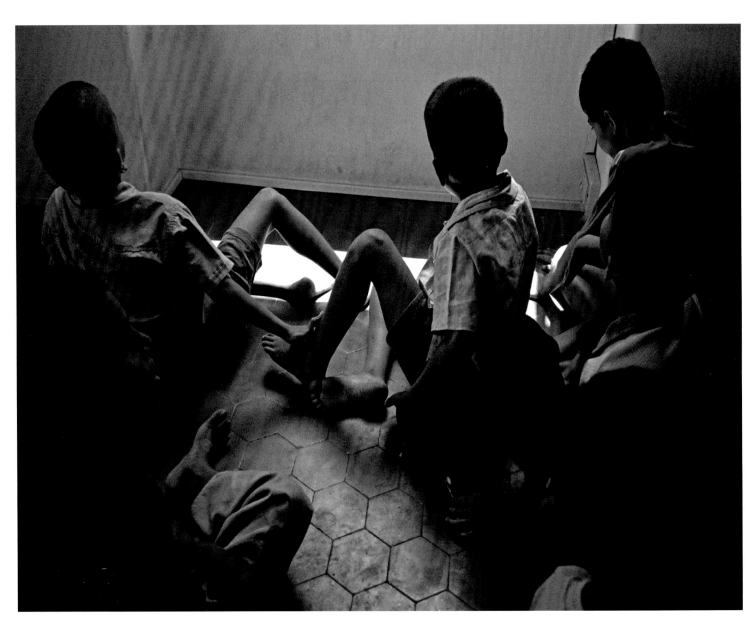

Rahul Shirsat, *Untitled*, India, 2006

PEDRO MIRANDA

The Mexican artist Pedro Miranda is a phenomenon. Photography is but a part of what he makes and does: he is a sculptor, a video artist, a maker of ceramics and original textile works. In one video he creates out of the noise of domestic objects a Cagean symphonic soundwork of genius.

As a photographer he has extended the boundaries of what photography itself can do, bringing to it a graphic mystery in one body of work, using textile supports for photographic images in another. Miranda takes his blindness into the world as a creative asset: he is a shape-changer, a change-maker.

"I feel just like any other artist and I think people who are blind photographers shouldn't include their disability as part of their professional title. There's nothing extraordinary about being a blind photographer! Those who think that way should think again as this job is carried out in the dark so, I can't see how it is supposed to be extraordinary."

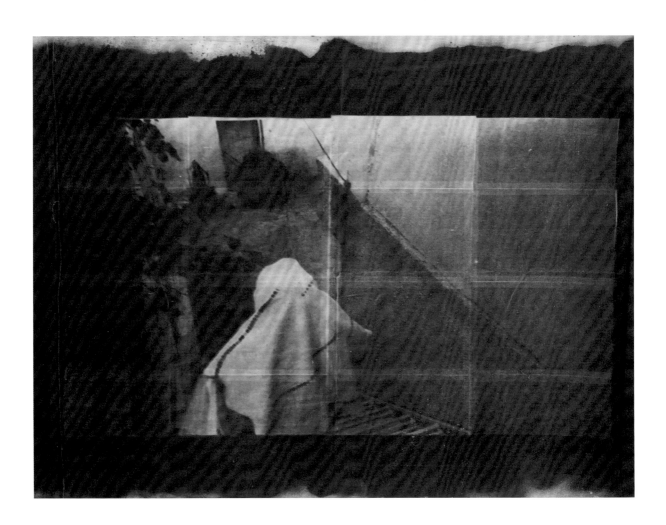

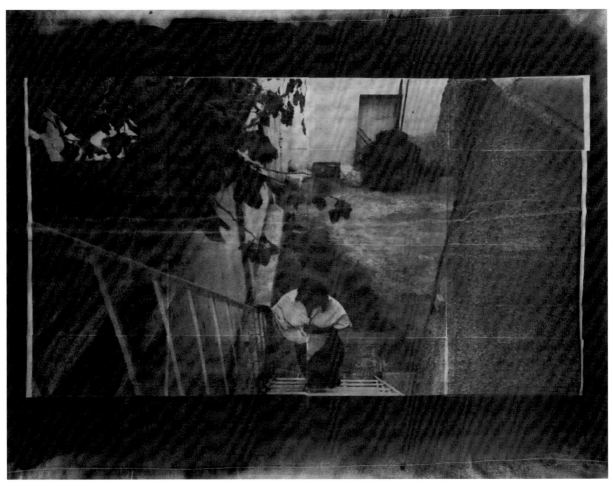

From the series *An Event on the Stairs, Mexico,* 1999 / 2013

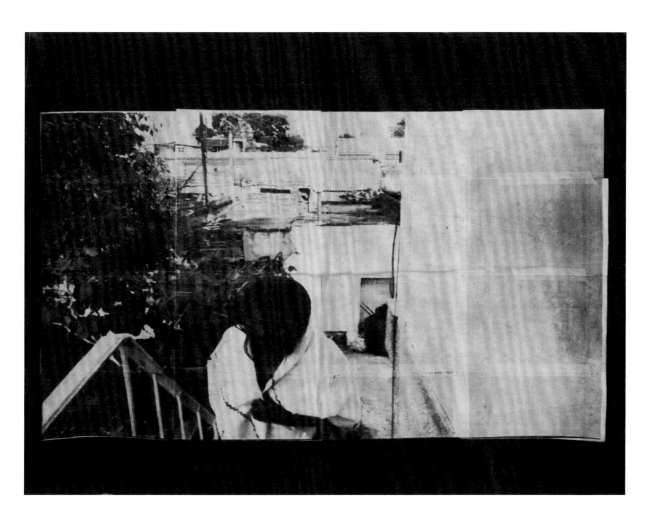

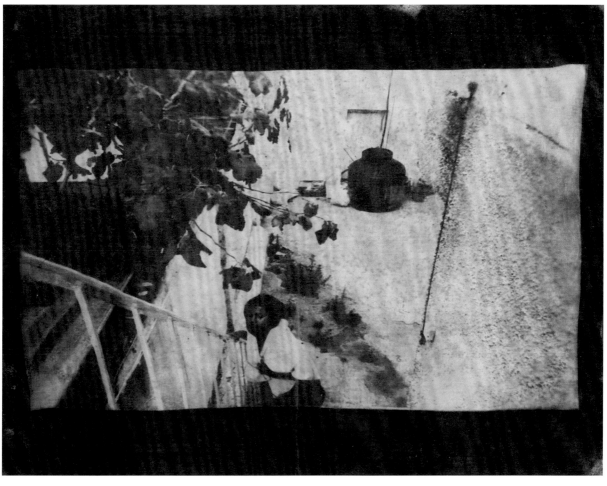

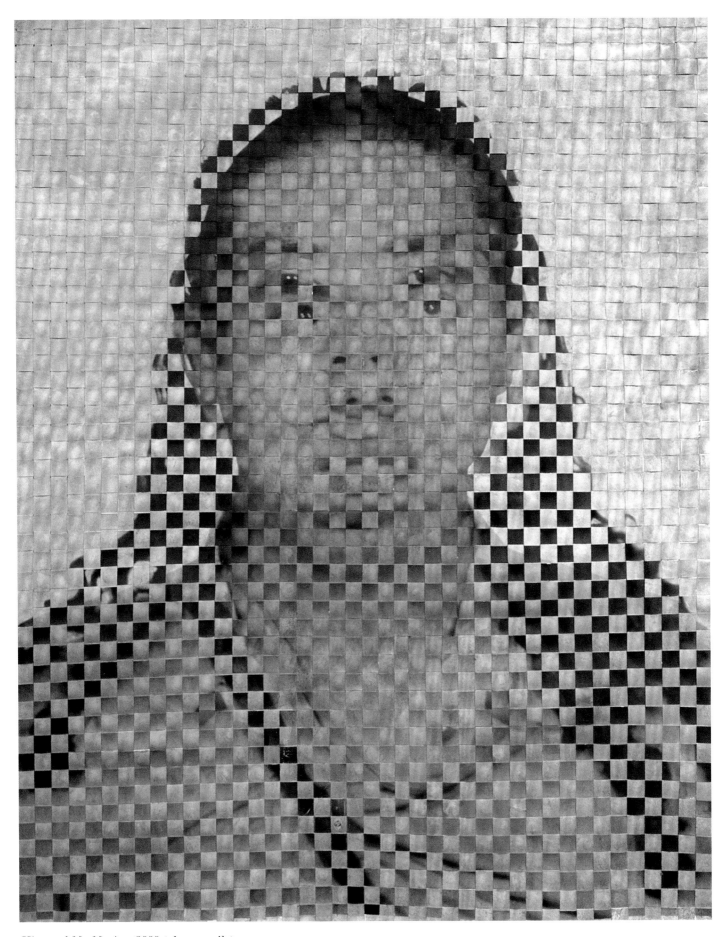

Him and Me, Mexico, 2009 (phototextile)

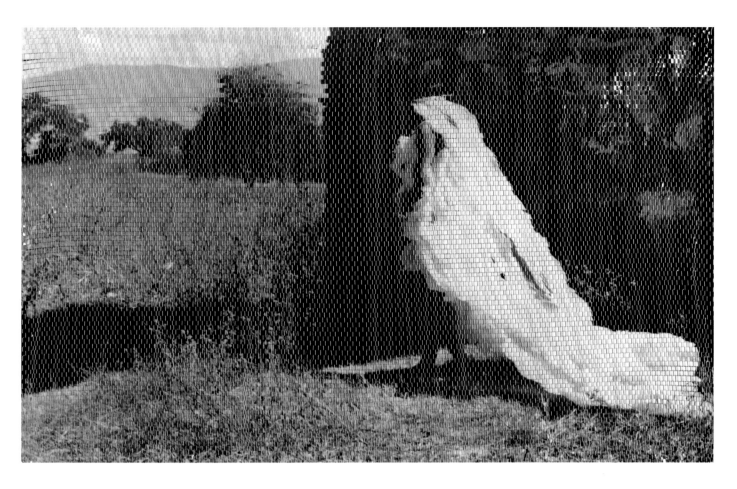

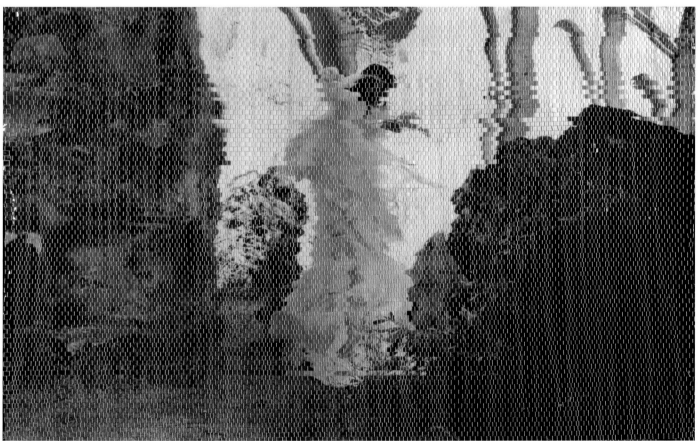

From the series *The Mad Bride*, Mexico, 2010 (phototextiles)

"Each image refers to the Oaxacan legend...after an earthquake knocked down the local church on her wedding day, the figure of a woman dressed as a bride appears looking for her lover among the abandoned rubble every night..."

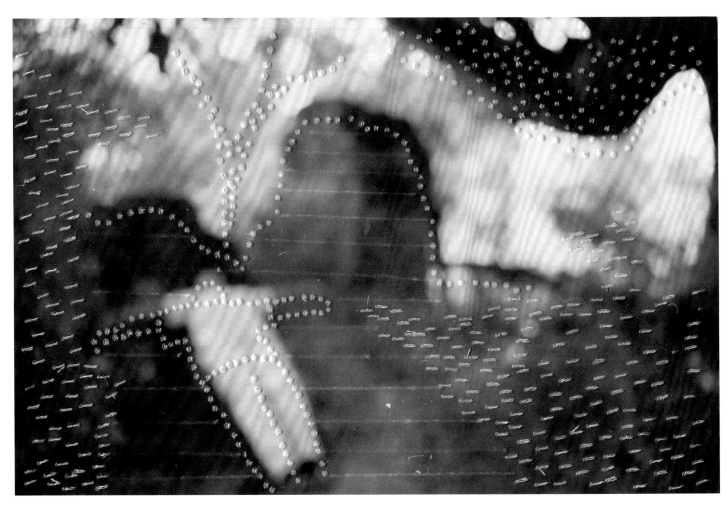

From the series *San Raymundo Jalpan through Reyna's eyes*, Mexico, 2001-2002

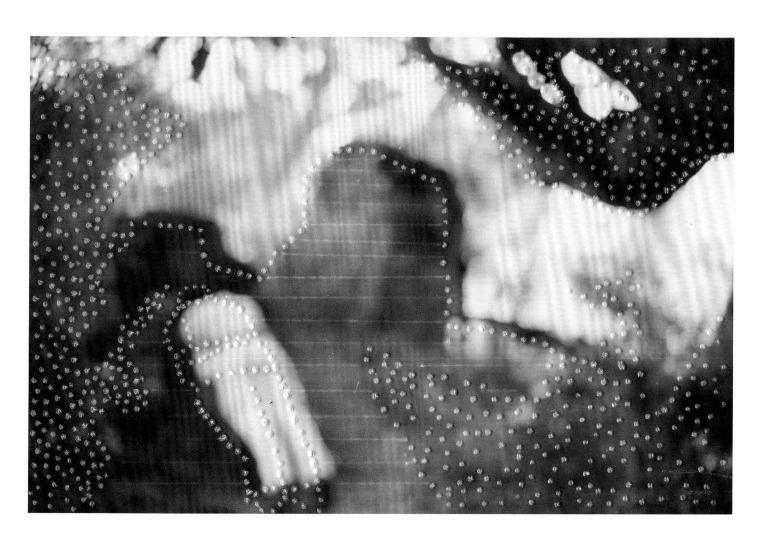

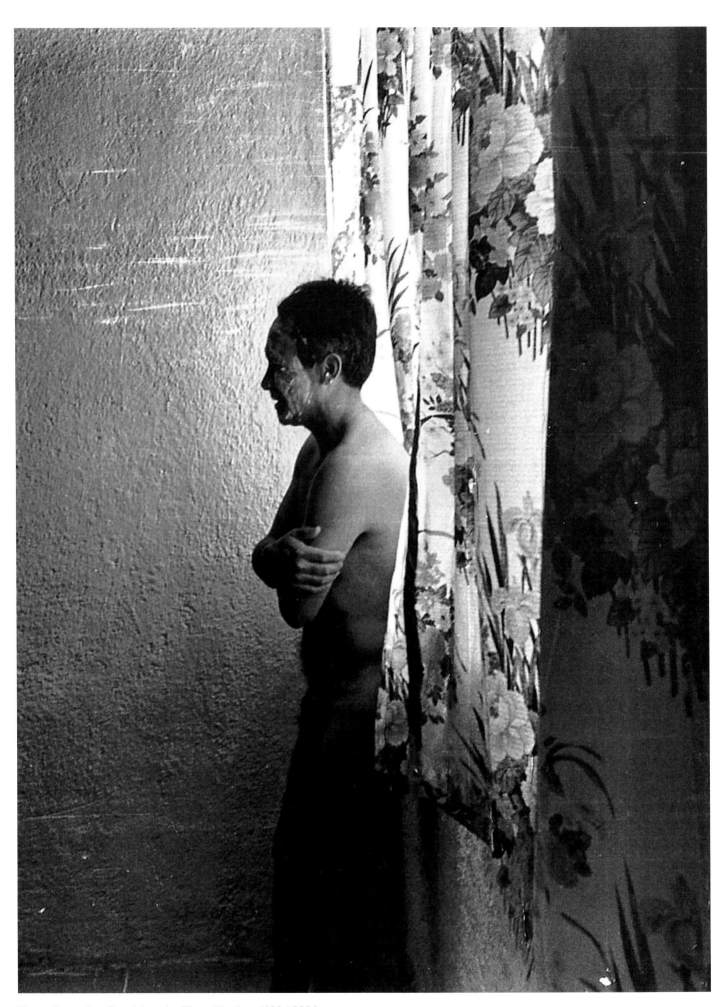

From the series *Surviving the Thaw*, Mexico, 1999 / 2004

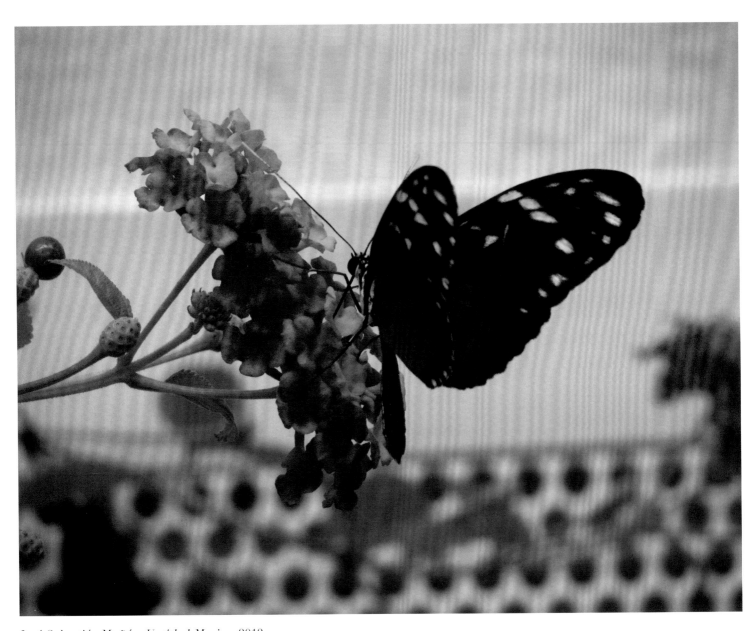

José Sebastián Muñóz, *Untitled*, Mexico, 2012

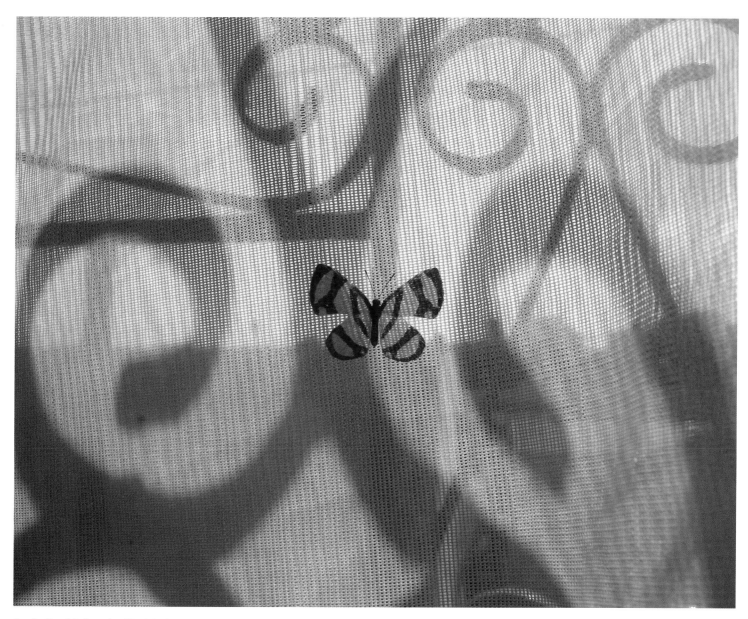

Jesús David García, *Untitled*, Mexico, 2011

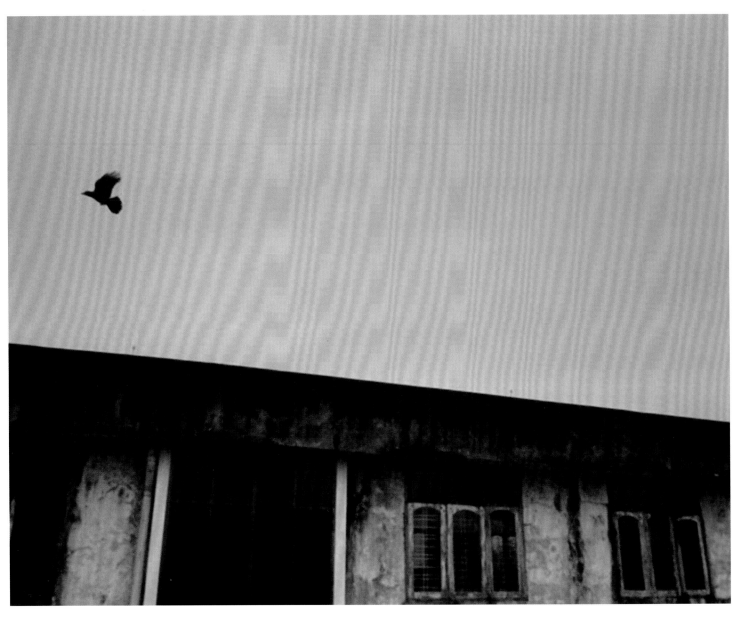

Ever Green, *Unstoppable Love Bird*, Myanmar, 2013

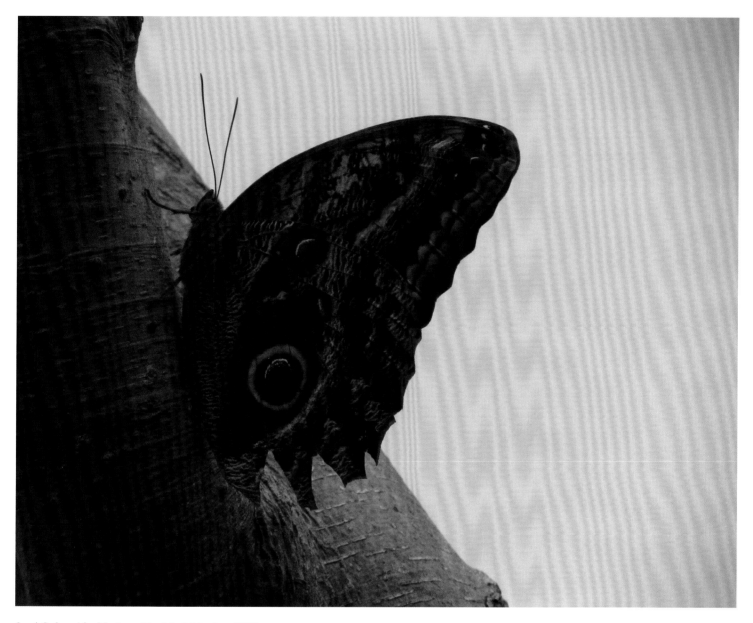

José Sebastián Muñoz, *Untitled*, Mexico, 2010

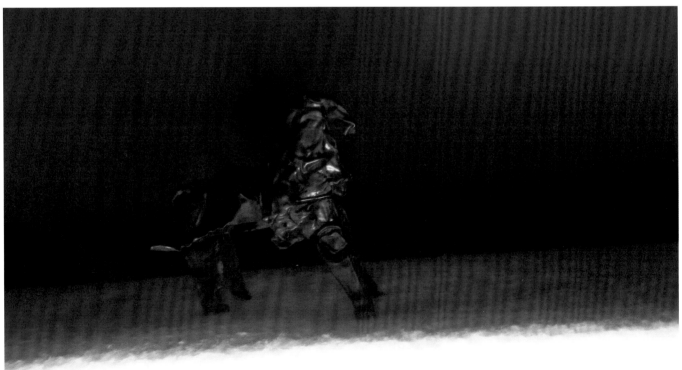

Marco Antonio Martínez, *Deep Dream*, Mexico, 2006

José Sebastián Muñóz, *Untitled*, Mexico, 2012

José Sebastián Muñóz, *Untitled*, Mexico, 2010

José Sebastián Muñóz, *Untitled*, Mexico, 2010

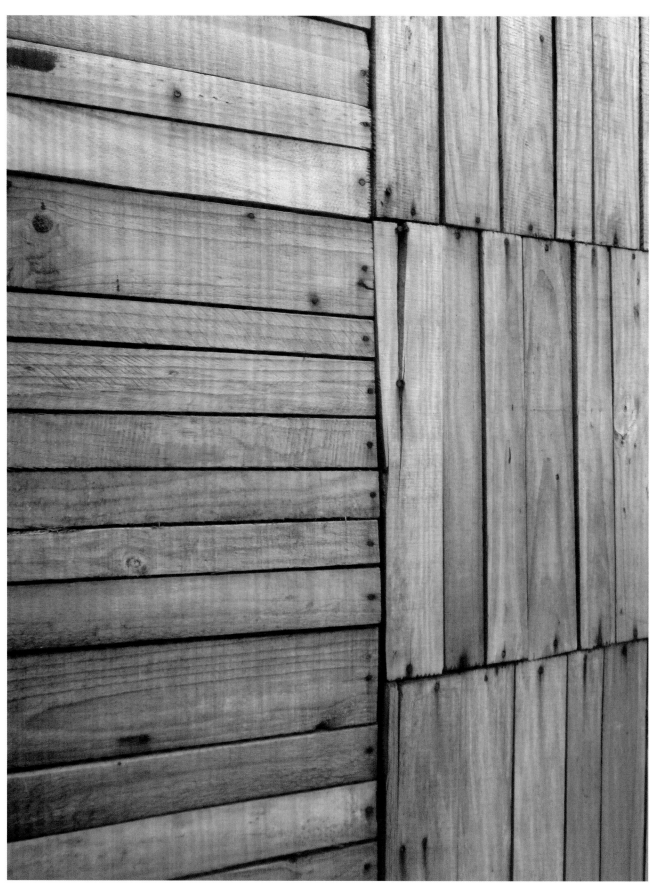

Daniel Apolinar, *Untitled*, Mexico 2013

Daniel Apolinar, *Untitled*, Mexico 2013

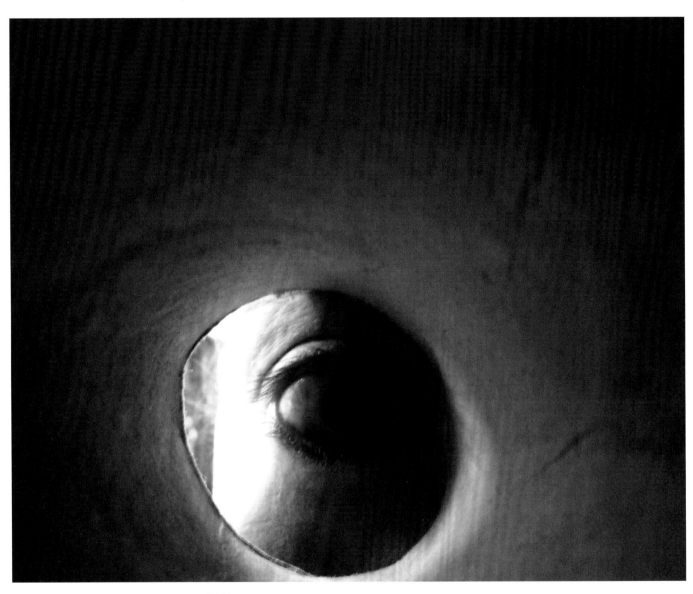

José Luis Mercado, *Unitled*, Mexico, 2013

FROM CHINA

There is no limit to the subjects and purposes of the blind photographer.

These photographs by Chinese photographers have a particular bias to a kind of sensory activism.

It is as if they are concerned with a desire to demonstrate through the photographic image the active participation of the blind subject in the things and situations of the world beyond blindness. Reach and touch, handle, breathe, listen, feel and smell the human world that presses upon you: in certain moments blindness becomes a gift to be savoured, felt along the senses.

Li Yan Shuang, *Untitled*, China, 2009

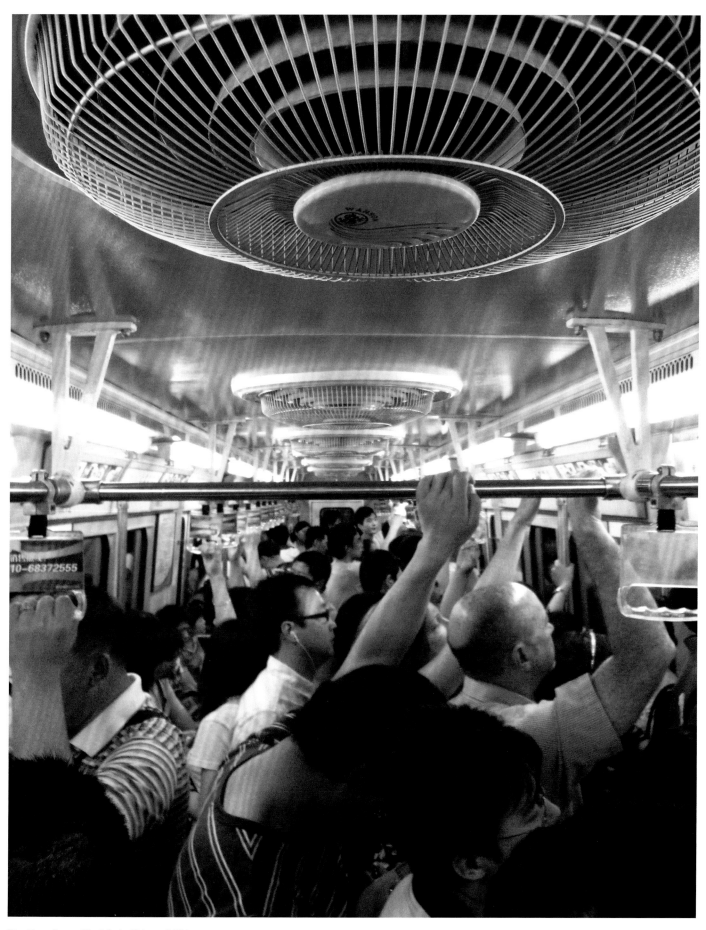

Fu Gaoshan, *Untitled*, China, 2009

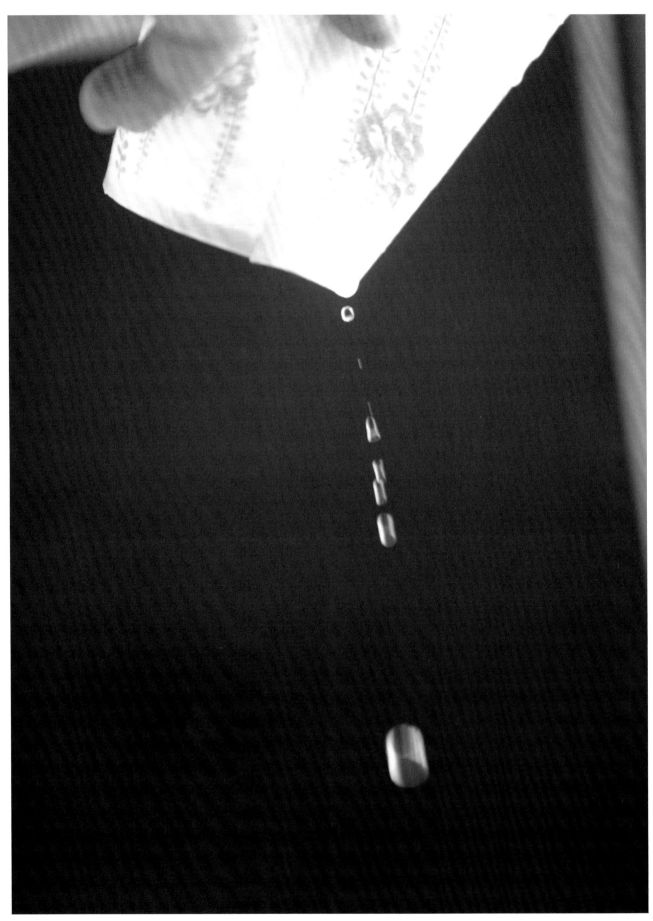

Li Yan Shuang, *Untitled*, China, 2009

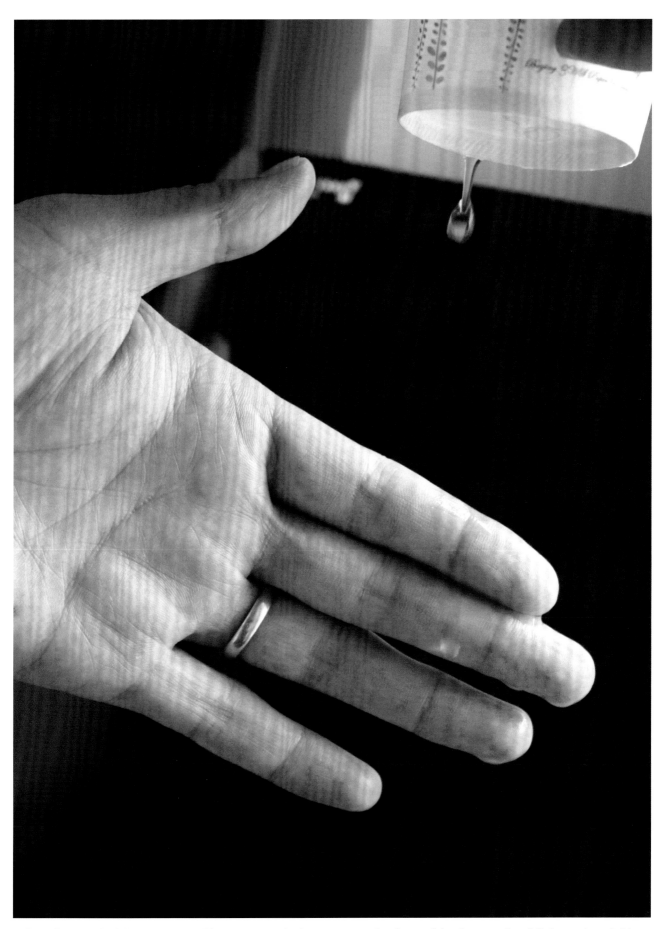

"I love the sound of dripping water. I have a strong desire to capture the shape of the drops as they fall down, though I have never been able to. That afternoon, I finally had the chance to capture this moment using my camera. Surprisingly, besides the water drop I caught, there is a hand in my picture."

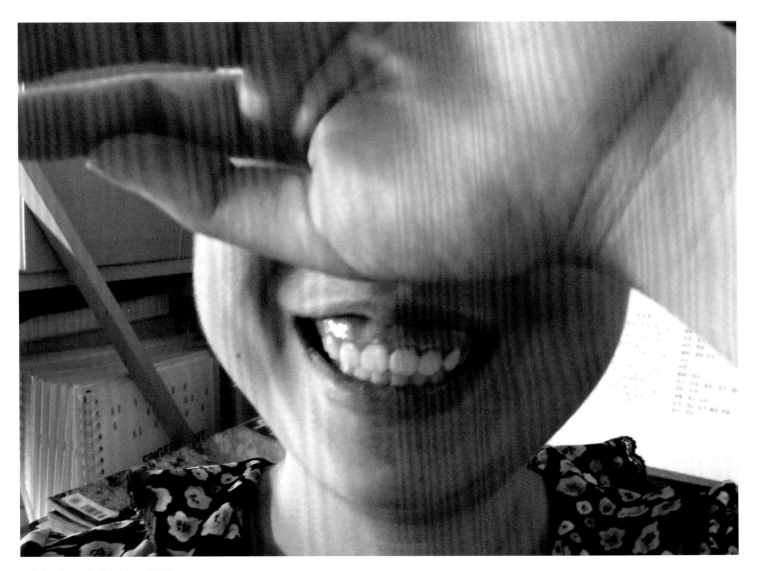

Li Qi, *Untitled*, China, 2009

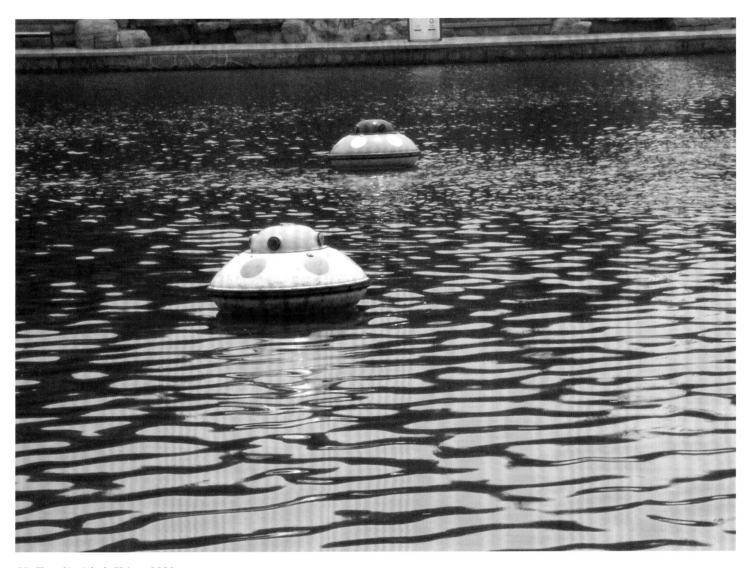

Ma Tao, *Untitled*, China, 2009

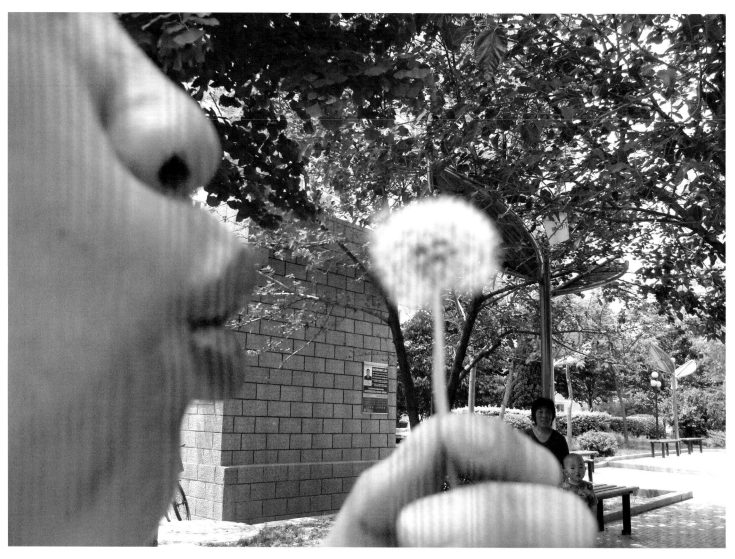

Jin Ling, *Watching dandelion, watching blowing dandelion*, China, 2009

AFTERWORD: JORGE LUIS BORGES

I have said that blindness is a way of life, a way of life that is not entirely unfortunate. Let us recall those lines of the greatest Spanish poet, Fray Luis de Leon:

> I want to live with myself,
>
> I want to enjoy the good that I owe to heaven,
>
> alone, without witnesses,
>
> free of love, of jealousy,
>
> of hate, of hope, of fear.

Edgar Allen Poe knew this stanza by heart. For me, to live without hate is easy, for I have never felt hate. To live without love I think is impossible, happily impossible for each one of us. But the first part –"I want to live with myself – I want to enjoy the good that I owe to heaven"–if we accept that in the good of heaven there can also be darkness, then who lives more with themselves? Who can explore themselves more? Who can know more of themselves? According to the Socratic phrase, who can know himself more than the blind man?

A writer lives. The task of being a poet is not completed at a fixed schedule. No one is a poet from eight to twelve and from two to six. Whoever is a poet is one always, and continually assaulted by poetry. I suppose a painter feels that colours and shapes are besieging him. Or a musician feels that the strange world of sounds – the strangest world of art – is always seeking him out, that there are melodies and dissonances looking for him. For the task of an artist, blindness is not a total misfortune. It may be an instrument. Fray Luis de Leon dedicated one of his most beautiful odes to Francisco Salinas, a blind musician.

A writer, or any man, must believe that whatever happens to him is an instrument; everything has been given for an end. This is even stronger in the case of the artist. Everything that happens, including humiliations, embarrassments, misfortunes, all has been given like clay, like material for one's art. One must accept it. For this reason I speak in a poem of the ancient food of heroes: humiliation, unhappiness, discord. Those things are given to us to transform, so that we may make from the miserable circumstances of our lives things that are eternal, or aspire to be so.

If a blind man thinks this way, he is saved. Blindness is a gift. I have exhausted you with the gifts it has given me. It gave me Anglo-Saxon, it gave me some Scandinavian, it gave me a knowledge of a Medieval literature I had ignored, it gave me the writing of various books, good or bad, but which justified the moment in which they were written. Moreover, blindness has made me feel surrounded by the kindness of others. People always feel good will toward the blind.

I want to end with a line of Goethe: *Alles Nahe werde fern*, everything near becomes distant. Goethe was referring to the evening twilight. Everything near becomes distant. It is true. At nightfall, the things closest to us seem to move away from our eyes. So the visible world has moved away from my eyes, perhaps forever. Goethe could be referring not only to twilight but to life. All things go off, leaving us. Old age is probably the supreme solitude – except that the supreme solitude is death. And "everything near becomes distant" also refers to the slow process of blindness, of which I hoped to show that it is not a complete misfortune. It is one more instrument among the man – all of them so strange – that fate or chance can provide.

Translated by Eliot Weinberger.